GRÜNEWALD

with an essay by J-K Huysmans

PHAIDON

The essay by J.-K. Huysmans, 'The Grünewalds in the Colmar Museum', first published in Trois Primitifs, was translated by Robert Baldick. The Biographical Note and Notes on the Plates are based on the Catalogue by E. Ruhmer in Grünewald, The Paintings (Phaidon Press, 1958).

The publishers are grateful to the museums and church authorities who have given permission to reproduce the paintings in their possession, especially those at Aschaffenberg, Friberg, Colmar and Karlsruhe, where works were specially photographed for this book by Gordon Roberton of A.C. Cooper Ltd.

Phaidon Press Limited, Littlegate House, St Ebbe's Street, Oxford
Published in the United States of America by E. P. Dutton & Co., Inc.

This edition first published 1976

ISBN 0 7148 1751 1
Library of Congress Catalog Card Number: 76-388

Printed in The Netherlands

GRÜNEWALD

The Grünewalds in the Colmar Museum

MATTHIAS GRÜNEWALD has fascinated me for many years. Whence did he come, what was his life, where and how did he die? Nobody knows for certain; his very name has been disputed, and the relevant documents are lacking; the pictures now accepted as his work were formerly attributed in turn to Albrecht Dürer, Martin Schongauer and Hans Baldung Grien, while others which he never painted are conceded to him by countless handbooks and museum catalogues. . .

It is not to Mainz, Aschaffenburg, Eisenach, or even to Isenheim, whose monastery is dead, that we must go to find Grünewald's works, but to Colmar, where the master displays his genius in a magnificent ensemble, a polyptych composed of nine pieces (Plates 8, 14, 18, 19, 26 and 27).

There, in the old Unterlinden convent, he seizes on you the moment you go in and promptly strikes you dumb with the fearsome nightmare of a *Calvary*. It is as if a typhoon of art had been let loose and was sweeping you away, and you need a few minutes to recover from the impact, to surmount the impression of awful horror made by the huge crucified Christ dominating the nave of this museum, which is installed in the old disaffected chapel of the convent.

The scene is arranged as follows:

In the centre of the picture a gigantic Christ, of disproportionate size if compared with the figures grouped around him, is nailed to a cross which has been roughly trimmed so that patches of bare wood are exposed here and there; the transverse branch, dragged down by the hands, is bent as in the Karlsruhe *Crucifixion* into the shape of a bow (Plates 9, 43). The body looks much the same in the two works: pale and shiny, dotted with spots of blood, and bristling like a chestnut-burr with splinters that the rods have left in the wounds; at the ends of the unnaturally long arms the hands twist convulsively and claw the air; the knees are turned in so that the bulbous knee-caps almost touch; while the feet, nailed one on top of the other, are just a jumbled heap of muscles underneath rotting, discoloured flesh and blue toe-nails; as for the head, it lolls on the bulging, sack-like chest patterned with stripes by the cage of the ribs. This crucified Christ would be a faithful replica of the one at Karlsruhe if the facial expression were not entirely different. Here, in fact, Jesus no longer wears the fearful rictus of tetanus; the jaw is no longer contracted, but hangs loosely, with open mouth and slavering lips.

Christ is less frightening here, but more humanly vulgar, more obviously dead. In the Karlsruhe panel the terrifying effect of the trismus, of the strident laugh, served to conceal the brutishness of the features, now accentuated by this imbecile slackness of the mouth. The Man-God of Colmar is nothing but a common thief who has met his end on the gallows.

That is not the only difference to be noted between the two works, for here the grouping of the figures is also dissimilar. At Karlsruhe the Virgin stands, as usual, on one side of the cross and St. John on the other; at Colmar the traditional arrangement is flouted, and the astonishing visionary that was Grünewald asserts himself, at once ingenious and ingenuous, a barbarian and a theologian, unique among religious painters.

On the right of the cross there are three figures: the Virgin, St. John and Magdalen. St. John, looking rather like an old German student with his peaky, clean-shaven face and his fair hair falling in long, dry wisps over a red robe, is holding in his arms a quite extraordinary Virgin, clad and coifed in white, who has fallen into a swoon, her face white as a sheet, her eyes shut, her lips parted to reveal her teeth. Her features are fine and delicate, and entirely modern; if it were not for the dark green dress which can be glimpsed close to the tightly clenched hands,

you might take her for a dead nun; she is pitiable and charming, young and beautiful. Kneeling in front of her is a little woman who is leaning back with her hands clasped together and raised towards Christ. This oldish, fair-haired creature, wearing a pink dress with a myrtle-green lining, her face cut in half below the eyes by a veil on a level with the nose, is Magdalen. She is ugly and ungainly, but so obviously inconsolable that she grips your heart and moves it to compassion.

On the other side of the picture, to the left of the cross, there stands a tall, strange figure with a shock of sandy hair cut straight across the forehead, limpid eyes, a shaggy beard, and bare arms, legs and feet, holding an open book in one hand and pointing to Christ with the other.

This tough old soldier from Franconia, with his camel-hair fleece showing under a loosely draped cloak and a belt tied in a big knot, is St. John the Baptist. He has risen from the dead, and in order to explain the emphatic, dogmatic gesture of the long, curling forefinger pointed at the Redeemer, the following inscription has been set beside his arm: *Illum oportet crescere, me autem minui.* 'He must increase, but I must decrease.'

He who decreased to make way for the Messiah, who in turn died to ensure the predominance of the Word in the world, is alive here, while He who was alive when he was defunct, is dead. It seems as if, in coming to life again, he is foreshadowing the triumph of the Resurrection, and that after proclaiming the Nativity before Jesus was born on earth, he is now proclaiming that Christ is born in Heaven, and heralding Easter. He has come back to bear witness to the accomplishment of the prophecies, to reveal the truth of the Scriptures; he has come back to ratify, as it were, the exactness of those words of his which will later be recorded in the Gospel of that other St. John whose place he has taken on the left of Calvary – St. John the Apostle, who does not listen to him now, who does not even see him, so engrossed is he with the Mother of Christ, as if numbed and paralysed by the manchineel of sorrow that is the cross.

So, alone in the midst of the sobbing and the awful spasms of the sacrifice, this witness of the past and the future, standing stolidly upright, neither weeps nor laments: he certifies and promulgates, impassive and resolute. And at his feet is the Lamb of the World that he baptized, carrying a cross, with a stream of blood pouring into a chalice from its wounded breast.

Thus arranged, the figures stand out against a background of gathering darkness. Behind the gibbet, which is planted on a river bank, there flows a stream of sadness, swift-moving yet the colour of stagnant water; and the somewhat theatrical presentation of the drama seems justified, so completely does it harmonize with this dismal setting, this gloom which is more than twilight but not yet night. Repelled by the sombre hues of the background, the eye inevitably turns from the glossy fleshtints of the Redeemer, whose enormous proportions no longer hold the attention, and fastens instead upon the dazzling whiteness of the Virgin's cloak, which, seconded by the vermilion of the apostle's clothes, attracts notice at the expense of the other parts, and almost makes Mary the principal figure in the work.

That would spoil the whole picture, but the balance, about to be upset in favour of the group on the right, is maintained by the unexpected gesture of the Precursor, who in his turn seizes your attention, only to direct it towards the Son.

One might almost say that, coming to this Calvary, one goes from right to left before arriving at the centre.

This is undoubtedly what the artist intended, as is the effect produced by the disproportion between the various figures, for Grünewald is a master of pictorial equilibrium and in his other works keeps everything in proportion. When he exaggerated the stature of his Christ he was trying to create a striking impression of profound suffering and great strength; similarly he made this figure more than usually remarkable in order to keep it in the foreground and prevent it from being completely eclipsed by the great patch of white that is the Virgin.

As for her, it is easy to see why he gave her such prominence, easy to understand his predilection for her – because never before had he succeeded in painting a

Madonna of such divine loveliness, such super-human sorrow. Indeed, it is astonishing that she should appear at all in the rebarbative work of this artist, so completely does she differ from the type of individual he has chosen to represent God and his saints.

His Jesus is a thief, his St. John a social outcast, his Precursor a common soldier. Even assuming that they are nothing more than German peasants, she is obviously of very different extraction; she is a queen who has taken the veil, a marvellous orchid growing among weeds.

Anyone who has seen both pictures – the one at Karlsruhe and the one at Colmar – will agree that there is a clear distinction between them. The Karlsruhe *Calvary* is better balanced and there is no danger of one's attention wandering from the principal subject. It is also less trivial, more awe-inspiring. You have only to compare the hideous rictus of its Christ and the possibly more plebeian but certainly less degraded face of its St. John with the coma of the Colmar Christ and the world-weary grimace of the disciple for the Karlsruhe panel to appear less conjectural, more penetrating, more effective, and, in its apparent simplicity, more powerful; on the other hand, it lacks the exquisite white Virgin and it is more conventional, less novel and unexpected. The Colmar *Crucifixion* introduces a new element into a scene treated in the same stereotyped fashion by every other painter; it dispenses with the old moulds and discards the traditional patterns. On reflexion, it seems to be the more imposing and profound of the two works, but it must be admitted that introducing the Precursor into the tragedy of Golgotha is more the idea of a theologian and a mystic than of an artist; here it is quite likely that there was some sort of collaboration between the painter and the purchaser, a commission described in the minutest detail by Guido Guersi, the Abbot of Isenheim, in whose chapel this picture was placed.

That, incidentally, was still the normal procedure long after the Middle Ages. All the archives of the period show that when contracting with image-carvers and painters – who regarded themselves as nothing more than craftsmen – the bishops or monks used to draw a plan of the proposed work, often even indicating the number of figures to be included and explaining their significance; there was accordingly only limited scope for the artist's own initiative, as he had to work to order within strictly defined bounds.

But to return to the picture, it takes up the whole of two wood panels which, in closing, cut one of Christ's arms in two, and, when closed, bring the two groups together.

The back of the picture (for it has two faces on either side) has a separate scene on each panel: a *Resurrection* on one and an *Annunciation* on the other (Plates 18, 19). Let me say straight away that the latter is bad, so that we can have done with it.

The scene is an oratory, where a book painted with deceptive realism lies open to reveal the prophecy of Isaiah, whose distorted figure, topped with a turban, is floating about in a corner of the picture, near the ceiling; on her knees in front of the book we see a fair-haired, puffy-faced woman, with a complexion reddened by the cooking-stove, pouting somewhat peevishly at a great lout with a no less ruddy complexion who is pointing two extremely long fingers at her in a truly comical attitude of reproach. It must be admitted that the Precursor's solemn gesture in the *Crucifixion* is utterly ridiculous in this unhappy imitation, where the two fingers are extended in what looks like insolent derision. As for the curly-wigged fellow himself, with that coarse, fat, red face you would take him for a grocer rather than an angel, if it were not for the sceptre he is holding in one hand and the green-and-red wings stuck to his back. And one can but wonder how the artist who created the little white Virgin could possibly represent Our Lord's Mother in the guise of this disagreeable slut with a smirk on her swollen lips, all rigged up in her Sunday best, a rich green dress set off by a bright vermilion lining.

But if this wing leaves you with a rather painful impression, the other one sends

you into raptures, for it is a truly magnificent work – unique, I would say, among the world's paintings. In it Grünewald shows himself to be the boldest painter who has ever lived, the first artist who has tried to convey, through the wretched colours of this earth, a vision of the Godhead in abeyance on the cross and then renewed, visible to the naked eye, on rising from the tomb. With him we are, mystically speaking, in at the death, contemplating an art with its back to the wall and forced further into the beyond, this time, than any theologian could have instructed the artist to go. The scene is as follows:

As the sepulchre opens, some drunks in helmet and armour are knocked head over heels to lie sprawling in the foreground, sword in hand; one of them turns a somersault further off, behind the tomb, and lands on his head, while Christ surges upwards, stretching out his arms and displaying the bloody commas on his hands.

This is a strong and handsome Christ, fair-haired and brown-eyed, with nothing in common with the Goliath whom we watched decomposing a moment ago, fastened by nails to the still green wood of a gibbet. All round this soaring body are rays emanating from it which have begun to blur its outline; already the contours of the face are fluctuating, the features hazing over, the hair dissolving into a halo of melting gold (Plates 19, 25). The light spreads out in immense curves ranging from bright yellow to purple, and finally shading off little by little into a pale blue which in turn merges with the dark blue of the night.

We witness here the revival of a Godhead ablaze with life: the formation of a glorified body gradually escaping from the carnal shell, which is disappearing in an apotheosis of flames of which it is itself the source and seat.

Christ, completely transfigured, rises aloft in smiling majesty; and one is tempted to regard the enormous halo which encircles him, shining brilliantly in the starry night like that star of the Magi in whose smaller orb Grünewald's contemporaries used to place the infant Jesus when painting the Bethlehem story – one is tempted to regard this halo as the morning star returning, like the Precursor in the *Crucifixion*, at night: as the Christmas star grown larger since its birth in the sky, like the Messiah's body since his Nativity on earth.

Having dared to attempt this *tour de force*, Grünewald has carried it out with wonderful skill. In clothing the Saviour he has tried to render the changing colours of the fabrics as they are volatilized with Christ. Thus the scarlet robe turns a bright yellow, the closer it gets to the light-source of the head and neck, while the material grows lighter, becoming almost diaphanous in this river of gold. As for the white shroud which Jesus is carrying off with him, it reminds one of those Japanese fabrics which by subtle gradations change from one colour to another, for as it rises it takes on a lilac tint first of all, then becomes pure violet, and finally, like the last blue circle of the nimbus, merges into the indigo-black of the night.

The triumphant nature of this ascension is admirably conveyed. For once the apparently meaningless phrase 'the contemplative life of painting' takes on a meaning, for with Grünewald we enter into the domain of the most exalted mysticism and glimpse, through the simulacra of colour and line, the well-nigh tangible emergence of the Godhead from its physical shell.

It is here, rather than in his horrific *Calvaries*, that the undeniable originality of this prodigious artist is to be seen.

This *Crucifixion* and this *Resurrection* are obviously the Colmar Museum's brightest jewels, but the amazing colourist that was Grünewald did not exhaust the resources of his art with these two pictures; we shall find more of his work, this time stranger yet less exalted, in another double-faced diptych which also stands in the middle of the old nave.

It depicts, on one side the Nativity and a concert of angels (Plate 14), on the other a visit from the Patriarch of the Cenobites to St. Paul the Hermit, and the temptation of St. Anthony (Plates 26, 27).

In point of fact, this *Nativity*, which is rather an exaltation of the divine Motherhood,

6

is one with the concert of angels, as is shown by the utensils, which overlap from one wing to the other and are cut in two when the panels are brought together.

The subject of this dual painting is admittedly obscure. In the left-hand wing the Virgin is seen against a distant, bluish landscape dominated by a monastery on a hill – doubtless Isenheim Abbey; on her left, beside a crib, a tub and a pot, a fig-tree is growing, and a rose-tree on her right. Fair-haired, with a florid complexion, thick lips, a high, bare brow and a straight nose, she is wearing a blue cloak over a carmine-coloured dress. She is not the servant-girl type, and has not come straight from the sheep-pen like her sister in the *Annunciation*, but for all that she is still just an honest German woman bred on beer and sausages: a farmer's wife, if you like, with servant-girls under her who look like the Mary of that other picture, but nothing more. As for the Child, who is very lifelike and very skilfully portrayed, he is a sturdy little Swabian peasant, with a snub nose, sharp eyes, and a pink, smiling face. And finally, in the sky above Jesus and Mary and below God the Father, who is smothered in clouds of orange and gold, swarms of angels are whirling about like scattered petals caught in a shower of saffron sunbeams.

All these figures are completely earthbound, and the artist seems to have realized this, for there is a radiance emanating from the Child's head and lighting up the Mother's fingers and face. Grünewald obviously wanted to convey the idea of divinity by means of these gleams of light filtering through the flesh, but this time he was not bold enough to achieve the desired effect: the luminous glow fails to conceal either the vulgarity of the face or the coarseness of the features.

So far, in any event, the subject is clear enough, but the same cannot be said of the complementary scene on the right-hand wing.

Here, in an ultra-Gothic chapel, with gold-scumbled pinnacles bristling with sinuous statues of prophets nestling among chicory, hop, knapweed and holly leaves, on top of slender pillars entwined by plants with singularly jagged leaves and twisted stems, are angels of every description, some in human form and others appearing simply as heads fitted into haloes shaped like funeral wreaths or collarettes: angels with pink or blue faces, angels with multicoloured or monochrome wings, angels playing the angelot or the theorbo or the viola d'amore, and all of them, like the pasty-faced, unhealthy-looking one in the foreground, gazing in adoration at the great Virgin in the other wing.

The effect is decidedly odd, but even odder is the appearance, beside these pure spirits and between two of the slender columns in the chapel, of another, smaller Virgin, this time crowned with a diadem of red-hot iron, who, her face suffused with a golden halo, her eyes cast down and her hands joined in prayer, is kneeling before the other Virgin and the Child.

What is the significance of this strange creature, who evokes the same weird impression as the girl with the cock and the money-pouch in Rembrandt's *Night Watch* – a girl likewise nimbed with a gentle radiance? Is this phantom queen a diminutive St. Anne or some other saint? She looks just like a Madonna, and a Madonna is what she must be. In painting her Grünewald has clearly tried to reproduce the light effect which blurs the features of Christ in his *Resurrection*, but it is difficult to see why he should do so here. It may be, of course, that he wanted to represent the Virgin, crowned after her Assumption, returning to earth with her angelic retinue to pay homage to that Motherhood which was her supreme glory; or, on the other hand, she may still be in this world, foreseeing the celebration of her triumph after her painful life among us. But this last hypothesis is promptly demolished by Mary's unheeding attitude, for she appears to be completely unaware of the presence of the winged musicians, and intent only on amusing the Child. In fact, these are all unsupported theories, and it would be simpler to admit that we just do not understand. I need only add that these two pictures are painted in loud colours which are sometimes positively shrill to make it clear that this faery spectacle presented in a crazy Gothic setting leaves one feeling vaguely uncomfortable.

As a refreshing contrast, however, one can always linger in front of the panel showing St. Anthony talking with St. Paul (Plate 26); it is the only restful picture in the whole series, and one is already so accustomed to the vehemence of the others that one is almost tempted to find it too unexciting, to consider it too anodyne.

In a rural setting that is all bright blue and moss green, the two recluses are sitting face to face: St. Anthony curiously attired, for a man who has just crossed the desert, in a pearl-grey cloak, a blue robe and a pink cap; St. Paul dressed in his famous robe of palms, which has here become a mere robe of rushes, with a doe at his feet and the traditional raven flying through the trees to bring him the usual hermit's meal of a loaf of bread.

In this picture the colouring is quiet and delicate, the composition superb: the subject may have put a certain restraint upon Grünewald, but he has lost none of the qualities which make him a great painter. To anyone who prefers the cordial, expected welcome of a pleasing picture to the uncertainties of a visit to some more turbulent work of art, this wing will undoubtedly seem the nicest, soundest and sanest of them all. It constitutes a halt in the man's mad gallop – but only a brief halt, for he sets off again almost at once, and in the next wing (Plate 27) we find him giving free rein to his fancy, caracolling along dangerous paths, and sounding a full fanfare of colours – as violent and tempestuous as he was in his other works.

The Temptation of St. Anthony must have given him enormous pleasure, for this picture of a demons' sabbath waging war on the good monk called for the most convulsive attitudes, the most extravagant forms and the most vehement colours. Nor was he slow to grasp this opportunity of exploiting the droller side of the supernatural. But if there is extraordinary life and colour in the *Temptation*, there is also utter confusion. Indeed, the picture is in such a tangle that it is impossible to distinguish between the limbs of the various devils, and one would be hard put to it to say which paw or wing beating or scratching the Saint belonged to which animal or bird.

The frantic hurly-burly in which these creatures are taking part is none the less captivating for that. It is true that Grünewald cannot match the ingenious variety and the very orderly disorder of a Bruegel or a Hieronymus Bosch, and that there is nothing here to compare with the diversity of clearly delineated and discreetly insane larvae which you find in the *Fall of the Angels* in the Brussels Museum: our painter has a more restricted fancy, a more limited imagination. He gives us a few demons' heads stuck with stags' antlers or straight horns, a shark's maw, and what appears to be the muzzle of a walrus or a calf; the rest of his supernumeraries all belong to the bird family, and with arms in place of feet look like the offspring of empuses that have been covered by angry cocks.

All these escapees from an infernal aviary are clustered excitedly around the anchorite, who has been thrown on his back and is being dragged along by his hair. Looking rather like a Dutch version of Father Becker with his flowing beard, St. Anthony is screaming with fear, trying to protect his face with one hand, and in the other clutching his stick and his rosary, which are being pecked at furiously by a hen wearing a carapace in lieu of feathers. The monstrous creatures are all closing in for the kill; a sort of giant parrot, with a green head, crimson arms, yellow claws and grey-gold plumage, is on the point of clubbing the monk, while another demon is pulling off his grey cloak and chewing it up, and yet others are joining in, swinging rib-bones and frantically tearing his clothes to get at him.

Considered simply as a man, St. Anthony is wonderfully lifelike in gesture and expression; and once you have taken your fill of the whole dizzy scramble, you may notice two thought-provoking details which you overlooked at first, hidden as they seem to be in the bottom corners. One, in the right-hand corner, is a sheet of paper on which a few lines are written; the other is a weird, hooded creature, sitting quite naked beside the Saint, and writhing in agony.

The paper bears this inscription: *Ubi eras Jhesu bone, ubi eras, quare non affuisti ut sanares vulnera mea?* – which can be translated as: 'Where were you, good Jesus,

where were you? And why did you not come and dress my wounds?'

This plaint, doubtless uttered by the hermit in his distress, is heard and answered, for if you look right at the top of the picture you will see a legion of angels coming down to release the captive and overpower the demons.

It may be asked whether this desperate appeal is not also being made by the monster lying in the opposite corner of the picture and raising his weary head heavenwards. And is this creature a larva or a man? Whatever it may be, one thing is certain: no painter has ever gone so far in the representation of putrefaction, nor does any medical textbook contain a more frightening illustration of skin disease. This bloated body, moulded in greasy white soap mottled with blue, and mamillated with boils and carbuncles, is the hosanna of gangrene, the song of triumph of decay!

Was Grünewald's intention to depict a demon in its most despicable form? I think not. On careful examination the figure in question is seen to be a decomposing, suffering human being. And if it is recalled that this picture, like the others, comes from the Anthonite Abbey of Isenheim, everything becomes clear. A brief account of the aims of this Order will, I think, suffice to explain the riddle.

The Anthonite or Anthonine Order was founded in the Dauphiné in 1093 by a nobleman called Gaston, whose son was cured of the burning sickness through the intercession of St. Anthony; its *raison d'être* was the care of people suffering from this type of disease. Placed under the Rule of St. Augustine, the Order spread rapidly across France and Germany, and became so popular in the latter country that during Grünewald's lifetime, in 1502, the Emperor Maximilian I granted it, as a mark of esteem, the right to bear the Imperial arms on its escutcheon, together with the blue tau which the monks themselves were to wear on their black habit.

Now there was at that time an Anthonite abbey at Isenheim, which had already stood there for over a century. The burning sickness was still rife, so that the monastery was in fact a hospital. We know too that it was the Abbot of Isenheim, or rather, to use the terminology of this Order, the Preceptor, Guido Guersi, who commissioned this polyptych from Grünewald.

It is now easy to understand the inclusion of St. Anthony in this series of paintings. It is also easy to understand the terrifying realism and meticulous accuracy of Grünewald's Christ-figures, which he obviously modelled on the corpses in the hospital mortuary; the proof is that Dr. Richet, examining his *Crucifixions* from the medical point of view, states that 'attention to detail is carried to the point of indicating the inflammatory halo which develops around minor wounds'. Above all, it is easy to understand the picture – painted from life in the hospital ward – of that hideous, agonized figure in the *Temptation*, which is neither a larva nor a demon, but simply a poor wretch suffering from the burning sickness.

It should be added that the written descriptions of this scourge which have come down to us correspond in every respect with Grünewald's pictorial description, so that any doctor who wants to know what form this happily extinct disease took can go and study the sores and the affected tissues shown in the painting at Colmar.*

The burning sickness, also known as holy fire, hell fire and St. Anthony's fire, first appeared in Europe in the tenth century, and swept the whole continent. It partook of both gangrenous ergotism and the plague, showing itself in the form of apostems and abscesses, gradually spreading to the arms and legs, and after burning them up, detaching them little by little from the torso. That at least is how it was described in the fifteenth century by the biographers of St. Lydwine, who was afflicted with the disease. Dom Félibien likewise mentions it in his History of Paris, where he says of the epidemic which ravaged France in the twelfth century: 'The victims' blood was affected by a poisonous inflammation which consumed the whole body, producing tumours which developed into incurable ulcers and caused thousands of deaths.'

*Two doctors have given their attention to this figure: Charcot and Richet. The former, in *Les Syphilitiques dans l'art*, sees it above all as a picture of the so-called 'Neapolitan disease'; the latter, in *L'Art et la Médecine*, hesitates between a disease of that type and leprosy.

What is certain is that not a single remedy proved successful in checking the disease, and that often it was cured only by the intercession of the Virgin and the saints.

The Virgin's intervention is still commemorated by the shrine of Notre-Dame des Ardents in Picardy, and there is a well-known cult of the holy candle of Arras. As for the saints, apart from St. Anthony, people invoked St. Martin, who had saved the lives of a number of victims gathered together in a church dedicated to him; prayers were also said to St. Israel, Canon of Le Dorat, to St. Gilbert, Bishop of Meaux, and finally to Geneviève. This was because, one day in the reign of Louis the Fat when her shrine was being carried in solemn procession around the Cathedral of Paris, she cured a crowd of people afflicted with the disease who had taken refuge in the basilica, and this miracle caused such a stir that, in order to preserve the memory of it, a church was built in the same city under the invocation of Sainte-Geneviève des Ardents; it no longer exists, but the Parisian Breviary still celebrates the Saint's feast-day under that name.

But to return to Grünewald, who, I repeat, has clearly left us a truthful picture of a victim of this type of gangrene, the Colmar Museum also contains a predella *Entombment*, with a livid Christ speckled with flecks of blood, a hard-faced St. John with pale ochre-coloured hair, a heavily veiled Virgin and a Magdalen disfigured by tears (Plate 8). However, this predella is merely a feeble echo of Grünewald's great Crucifixions: it would be astounding, seen on its own in a collection of canvases by other painters, but here it is not even astonishing.

Mention must be made as well of two rectangular wings: one depicting a little bandy-legged St. Sebastian larded with arrows (Plate 13); the other – a panel cited by Sandrart – St. Anthony holding the Tau, the crozier of his Order – a St. Anthony so solemn and so thoughtful that he can even ignore the demon busily breaking window-panes behind him (Plate 12). And that brings us to the end of our review of this master-painter's works. You take leave of him spellbound for ever. And if you look for his origins you will look in vain, for none of the painters who preceded him or who were his contemporaries resembles him.

One can perhaps discern a certain foreign influence in Grünewald's work; as Goutzwiller points out in his booklet on the Colmar Museum, it is possible to see a reminiscence or a vague imitation of the contemporary Italian landscape manner in the way in which he plans his settings and sprinkles his skies with blue. Had he travelled in Italy, or had he seen pictures by Italian masters in Germany – perhaps at Isenheim itself, since the Preceptor Guido Guersi, to judge by his name, hailed from beyond the Alps? No one knows; but in any event, the very existence of this influence is open to question. It is, in fact, by no means certain that this man who anticipates modern painting, reminding one sometimes of Renoir with his acid colours and of the Japanese with his skilful nuances, did not arrange his landscapes without benefit of memories or copies, painting them from nature as he found them in the countryside of Thuringia or Swabia; for he could easily have seen the bright bluish blackcloth of his *Nativity* in those parts. Nor do I share Goutzwiller's opinion that there is an unmistakable 'Italian touch' in the inclusion of a cluster of palm-trees in the picture of the two anchorites (Plate 26). The introduction of this type of tree into an Oriental landscape is so natural and so clearly called for by the subject that it does not imply any outside suggestion or influence. In any event, if Grünewald did know the work of foreign artists, it is surprising that he should have confined himself to borrowing their method of arranging and depicting skies and woods, while refraining from copying their technique of composition and their way of painting Jesus and the Virgin, the angels and the saints.

His landscapes, I repeat, are definitely German, as is proved by certain details. These may strike many people as having been invented to create an effect, to add a note of pathos to the drama of Calvary, yet in fact they are strictly accurate. This is certainly true of the bloody soil in which the Karlsruhe cross is planted, and which is no product of the imagination (Plate 43). Grünewald did much of

his painting in Thuringia, where the earth, saturated with iron oxide, is red; I myself have seen it sodden with rain and looking like the mud of a slaughter-house, a swamp of blood.

As for his human figures, they are all typically German, and he owes just as little to Italian art when it comes to the arrangement of dress fabrics. These he has really woven himself, and they are so distinctive that they would be sufficient in themselves to identify his pictures among those of all other painters. With him we are far removed from the little puffs, the sharp elbows and the short frills of the Primitives; he drapes his clothes magnificently in flowing movements and long folds, using materials that are closely woven and deeply dyed. In the Karlsruhe *Crucifixion* they have something about them suggestive of bark ripped from a tree: the same harsh quality as the picture itself. At Colmar this impression is not so pronounced, but they still reveal the multiplicity of layers, the slight stiffness of texture, the ridges and the hollows which are the hallmark of Grünewald's work; this is particularly true of Christ's loin-cloth and St. John the Baptist's cloak.

Here again he is nobody's pupil, and we have no alternative but to put him down in the history of painting as an exceptional artist, a barbarian of genius who bawls out coloured prayers in an original dialect, an outlandish tongue.

His tempestuous soul goes from one extreme to another, restless and storm-tossed even during moments of deliberate repose; but just as it is deeply moving when meditating on the episodes of the Passion, so it is erratic and well-nigh baroque when reflecting on the joys of the Nativity. The truth is that it simpers and stammers when there is no torturing to be done, for Grünewald is the painter of tombs rather than cribs, and he can only depict the Virgin successfully when he makes her suffer. Otherwise he sees her as red-faced and vulgar, and there is such a difference between his Madonnas of the sorrowful mysteries and his Madonnas of the joyful mysteries that one wonders whether he was not following an aesthetic system, a scheme of intentional antitheses.

It is, indeed, quite likely that he decided that the quality of divine Motherhood would only come out clearly under the stress of the suffering endured at the foot of the cross. This theory would certainly fit in with the one he adopted whenever he wished to glorify the divine nature of the Son, for he always painted the living Christ as the Psalmist and Isaiah pictured him – as the poorest and ugliest of men – and only restored his divine appearance to him after his Passion and death. In other words, Grünewald made the ugliness of the crucified Messiah the symbol of all the sins of the world which Christ took upon himself, thus illustrating a doctrine which was expounded by Tertullian, St. Cyprian, St. Cyril, St. Justin and countless others, and which was current for a good part of the Middle Ages.

He may also have been the victim of a technique which Rembrandt was to use after him: the technique of suggesting the idea of divinity by means of the light emanating from the very face that is supposed to represent it. Admirable in his *Resurrection of Christ* (Plate 19), this secretion of light is less convincing when he applies it to the little Virgin in the *Angelic Concert* and completely ineffective when he uses it to portray the fundamentally vulgar Child in the *Nativity* (Plate 14).

He probably placed too much reliance on these devices, crediting them with an efficacy they could not possess. It should, indeed, be noted that, if the light spinning like an artificial sun around the risen Christ suggests to us a vision of a divine world, it is because Christ's face lends itself to that idea by its gentle beauty. It strengthens rather than weakens the significance and effect of that huge halo, which in turn softens and enhances the features, veiling them in a mist of gold.

Such is the complete Grünewald polyptych in the Colmar Museum. I do not intend to deal here with those paintings attributed to him which are scattered among other art-galleries and churches, and which for the most part are not his work. I shall also pass over the Munich *St. Erasmus and St. Maurice*, which, if it must be accepted as his work, is cold and uncharacteristic (Plate 38); I shall even

set aside the *Fall of Jesus*, which like the famous *Crucifixion* has been transferred from Cassel to Karlsruhe, and which is undoubtedly genuine (Plate 42). It shows a blue-clad Christ on his knees, dragging his cross, in the midst of a group of soldiers dressed in red and executioners dressed in white with pistachio stripes. He is gritting his teeth and digging his fingernails into the wood, but his expression is less of suffering than of anger, and he looks like a damned soul. This, in short, is a bad Grünewald.

Confining myself therefore to the brilliant, awe-inspiring flower of his art, the Karlsruhe *Crucifixion* and the nine pieces at Colmar, I find that his work can only be defined by coupling together contradictory terms.

The man is, in fact, a mass of paradoxes and contrasts. This Orlando furioso of painting is forever leaping from one extravagance to another, but when necessary the frenzied demoniac turns into a highly skilled artist who is up to every trick of the trade. Though he loves nothing better than a startling clash of colours, he can also display, when in good form, an extremely delicate sense of light and shade – his *Resurrection* is proof of that – and he knows how to combine the most hostile hues by gently coaxing them together with adroit chromatic diplomacy.

He is at once naturalistic and mystical, savage and sophisticated, ingenuous and deceitful. One might say that he personifies the fierce and pettifogging spirit of the Germany of his time, a Germany excited by the ideas of the Reformation. Was he involved, like Cranach and Dürer, in that emotional religious movement which was to end in the most austere coldness of the heart, once the Protestant swamp had frozen over? I cannot say – though he certainly lacks nothing of the harsh fervour and vulgar faith which characterized the illusory springtide of the early sixteenth century. For me, however, he personifies still more the religious piety of the sick and the poor. That awful Christ who hung dying over the altar of the Isenheim hospital would seem to have been made in the image of the ergotics who prayed to him; they must surely have found consolation in the thought that this God they invoked had suffered the same torments as themselves, and had become flesh in a form as repulsive as their own; and they must have felt less forsaken, less contemptible. It is easy to see why Grünewald's name, unlike the names of Holbein, Cranach and Dürer, is not to be found in the account-books or the records of commissions left by emperors and princes. His pestiferous Christ would have offended the taste of the courts; he could only be understood by the sick, the unhappy and the monks, by the suffering members of Christ.

<div align="right">J.-K. HUYSMANS</div>

Biographical note

The artist's real name was probably Mathis Gothardt; sometimes he also used the surname Neithardt. The name Grünewald, by which he is now generally known, was attached to him in error 150 years after his death.

He was probably born in Würzburg between 1470 and 1475. By 1500 he was a 'free master' and settled in the small town of Seligenstadt, where he bought a house and a pond and opened a workshop for painters and wood-carvers. Soon afterwards he became court painter to the Archbishop of Mainz, and to his successor, Albrecht of Brandenburg, Archbishop of Magdeburg, later bishop and Elector of Mainz and, from 1518, Cardinal. Grünewald served the Cardinal also as a hydraulic engineer and as supervisor of new buildings in Halle. Among his other patrons were a canon in Aschaffenburg and the 'preceptor' of the Anthonite monastery at Isenheim in Alsace. Albrecht of Brandenburg at first showed toleration and even sympathy for the Lutheran Reformation, but soon became an implacable opponent, and it is possible that Grünewald had to leave his service because he had supported the Peasant Rising of 1525. In 1526 he moved to Frankfurt and in the following year to Halle, where he died in August 1528.

Plates

Plate 1. *The Mocking of Christ.* 1503? Pinewood, 109 × 73·5 cm. Munich, Alte Pinakothek.

Plate 2. *St. Elizabeth of Hungary, wife of Ludwig of Thuringia.* 1511–2. Grisaille on pinewood, 95·8 × 42·8 cm. Karlsruhe, Kunsthalle (from Donaueschingen).

Plate 3. *St. Lucy (?) with the palm of martyrdom.* 1511–2. Grisaille on pinewood, 101·2 × 43·7 cm. Karlsruhe, Kunsthalle (from Donaueschingen).

Plate 4. *St. Cyriac and the Princess Artemia.* 1511–2. Grisaille on pinewood, 98·8 × 43·8 cm. Frankfurt, Staedel Institute.
St. Cyriac cured the frenzied Princess Artemia, daughter of Diocletian. On the pages of the open book are the words of the exorcizing formula.

Plate 5. *St. Lawrence with the gridiron.* 1511–2. Grisaille on pinewood, 99·1 × 43·2 cm. Frankfurt, Staedel Institute.

Plate 6. *Christ on the Cross, with the Three Maries, St. John the Evangelist and St. Longinus.* Limewood, 1513–4? 75 × 54·4 cm. Basel, Öffentliche Kunstsammlung.
The words VERE·FILIUS DEI ERAT ISTE (St. Mark, xv. 39.) appear between the head and raised arms of Longinus. Just visible in the background are The Agony in the Garden (left), five heads of angels (top left) and soldiers moving away (right).

Plate 7. *Christ on the Cross, with the Virgin, St. John the Evangelist and St. Mary Magdalen.* About 1519. Limewood, 61·5 × 46 cm. Washington, D.C., National Gallery of Art (Samuel H. Kress Collection).

Plate 8. *Christ on the Cross, with the Virgin, St. John the Evangelist, St. Mary Magdalen and St. John the Baptist* (269 × 307 cm.); *St. Anthony Abbot* (232 × 75 cm.); *St. Sebastian* (232 × 76·5 cm.); *The Dead Christ in the Tomb, mourned by the Virgin, St. John the Evangelist and St. Mary Magdalen.* (67 × 34 cm.) Colmar, Unterlinden Museum.
These paintings comprise the first stage of the Isenheim Altarpiece; the second stage is illustrated in Plates 14, 18 and 19 and the third stage in Plates 26 and 27.

The donors were Johann von Orliaco and Guido Guersi, both preceptors of the Anthonite monastery, Isenheim (Alsace), in whose hospital patients were treated for epilepsy, blood and skin diseases. Patients were brought to the high altar of the church before receiving medical treatment, to be assured of the possibility of participating in a miracle.

As early as 1656/7 the altarpiece (or a copy of the Crucifixion?) seems to have been moved from its original place. In 1793/4 it was dismembered by the French, when the superstructure was destroyed except for a few fragments which are now in the Unterlinden Museum at Colmar. Thanks to the Colmar painter L. L. Karpff, called Kasimir, the paintings and sculpture were saved from similar destruction. They were moved from the Colmar Jesuit College to the Chapel of the Unterlinden Monastery.

The altarpiece contains an unusual number of *pentimenti* which give an interesting insight into Grünewald's method of working. Thus the Head of Christ was not originally brought down so low, whilst the right upper arm – which was altered at least three times – was drawn up. The Virgin originally stood up straight, the drapery fell diagonally to the back, her eyes were open and fixed on Christ. St. John was not holding her, his right arm and hand have been altered several times. The same applies to the head of Mary Magdalen. St. John the Baptist's finger was not originally bent up so much.

Heinrich Feurstein (1930) was the first to point out that *The Revelations of St. Bridget of Sweden* (1303/73), first published in Lübeck in 1492 and in Nürnberg in 1502, was possibly the source of the whole altarpiece, as is particularly apparent

in the Crucifixion: 'Thou art the Lamb that John pointed out with his finger... His feet were curled round the nails as round door hinges towards the other side.'

The altarpiece is carved and painted on limewood. The original overall measurements were 8 × 5 m.

Plate 9. *Christ on the Cross.* Detail from Plate 8.

Plate 10. *The Virgin and St. John the Evangelist.* Detail from Plate 9.

Plate 11. *St. Sebastian.* Detail from Plate 13.

Plate 12. *St. Anthony Abbot.* Detail from Plate 8.

Plate 13. *St. Sebastian.* Detail from Plate 8.

Plate 14. *The Virgin and Child with Angels making music* (The Isenheim Altarpiece). 265 × 304 cm. Colmar, Unterlinden Museum.

Plate 15. *Angels making music.* Detail from Plate 14.

Plate 16. *St. Anthony Abbot.* Detail from Plate 26.

Plate 17. *The Virgin and Child.* Detail from Plate 14.

Plate 18. *The Annunciation* (Wing of the Isenheim Altarpiece). 269 × 142 cm. Colmar, Unterlinden Museum.

Plate 19. *The Resurrection* (Wing of the Isenheim Altarpiece). 269 × 143 cm. Colmar, Unterlinden Museum.

Plate 20. *Angels making music.* Detail from Plate 14.

Plate 21. *Two soldiers.* Detail from Plate 19.

Plate 22. *The Prophet Isaiah.* Detail from Plate 18.

Plate 23. *The Prophets.* Detail from Plate 14.

Plate 24. *The Archangel Gabriel.* Detail from Plate 18.

Plate 25. *The Risen Christ.* Detail from Plate 19.

Plate 26. *The Meeting of St. Anthony Abbot and St. Paul the Hermit in the Wilderness* (Wing of the Isenheim Altarpiece). 265 × 141 cm. Colmar, Unterlinden Museum.

Plate 27. *St. Anthony Abbot assailed by monstrous demons* (Wing of the Isenheim Altarpiece). 265 × 139 cm. Colmar, Unterlinden Museum.

Plate 28a. *Man afflicted by St. Anthony's fire, and a monstrous demon.* Detail from Plate 27.

Plate 28b. *Overgrown stone base.* Detail from Plate 12.

Plate 29. *Monstrous demons.* Detail from Plate 27.

Plate 30. *Deer.* Detail from Plate 26.

Plate 31. *Monstrous demons.* Detail from Plate 27.

Plate 32. *Raven bringing bread to St. Anthony Abbot and St. Paul the Hermit.* Detail from Plate 26.

Plate 33. *Landscape with monastery and a vision of angels.* Detail from Plate 34.

Plate 34. *Madonna in the Garden* (Part of the Maria-Schnee Altarpiece). 1517–9. Pinewood, lined with canvas, 185 × 150 cm. Stuppach (Württemberg), Parish Church.

This painting forms part of the Maria Schnee (Our Lady of the Snows) Altarpiece at Stuppach. Attempts have been made to find a more profound interpretation for the Stuppach Madonna, though on the face of it, it seems in no way unusual. The rainbow above the Virgin's head and the church in the background on the right are the symbols used by St. Bridget, the beehive and the closed garden gate in the background, left, are common symbols of the Virgin, and the low figtree on the left recalls Christ's parable of the figtree. The Virgin Mary, the church of the Virgin Mary and beehive represent the 'triple house of God'.

Plate 35. *The Miracle of the Snows* (Part of the Maria-Schnee Altarpiece). 1517–9. Pinewood, 179 × 91·5 cm. Freiburg im Breisgau, Augustinermuseum.

The following details refer to the subject-matter of the Miracle of the Snows. According to the legend, the Roman citizen John, who was considering the donation of a church to the Virgin, dreamed on the night of 3 August in the year 352 that

Our Lady had caused snow to fall on a certain spot on the Esquiline in order to reveal the building-site for the promised church. Pope Liberius (represented in the background left, sleeping in an open room) had the same dream the same night. He immediately ordered a procession to go to the spot seen in the dream and there they found the fallen snow. Using a tool he had brought with him the Holy Father dug up the first spade-full with his own hand: this is the chief scene on the Freiburg panel. On the left the patrician John (with the features of the St. Paul of the Two Hermits on the Isenheim Altarpiece (Plate 26) and related to the Erlangen 'self-portrait' drawing) kneels with his wife.

Plate 36. *Vase of lilies and roses.* Detail from Plate 34.

Plate 37. *The retinue of Pope Liberius and a fanciful view of the Esquiline Hill.* Detail from Plate 35.

Plate 38. *The Disputation of St. Erasmus and St. Maurice.* 1524–5. Pinewood, 226 × 176 cm. Munich, Alte Pinakothek.

St. Erasmus, Bishop of Antioch (left), is identified by the windlass and the intestines he carries, but his features are those of Cardinal Albrecht. Albrecht founded the Abbey at Halle which contained some 6,000 relics, including the bones and head of St. Erasmus, and of which St. Erasmus was the first patron saint, and St. Maurice, Leader of the Theban Legion, the second.

Although the saints were contemporaries of about A.D. 300, the meeting was allegorical rather than historical; Erasmus suffered martyrdom under Diocletian, Maurice, a Roman officer, was converted to Christianity but executed, together with his troops, whilst on his way to suppress a Christian uprising in Gaul.

The significance of this meeting is not altogether clear. It more probably represents a religious disputation than a conversion scene, but possibly represents the welcoming of the new patron saint by the old one.

Plate 39. *St. Maurice.* Detail from Plate 38.

Plate 40. *Dead Christ.* 1523? Pinewood, 36 × 136 cm. Aschaffenburg, Collegiate Church.

On the left are the arms of Cardinal Albrecht, Archbishop of Magdeburg, and on the right are those of one of his predecessors, Count Dietrich von Erlach, Archbishop of Mainz until 1459.

Plate 41. *Head of Christ.* Detail from Plate 40.

Plate 42. *Christ carrying the Cross.* About 1526. Pinewood, 195·5 × 152·5 cm. Karlsruhe, Kunsthalle.

The inscription, ESIAS. 53. ER. IST. VMB. VNSER. SVND. WILLEN. GESCLAGEN. (He was beaten for our sins) was most probably taken from a Passion Play.

Plate 43. *Christ on the Cross, with the Virgin and St. John the Evangelist.* About 1526. Pinewood, 195·5 × 152·5 cm. Karlsruhe, Kunsthalle.

In its quiet symmetry the Karlsruhe Crucifixion is the most classic of Grünewald's paintings, his unequivocal 'Renaissance work'. Plates 42 and 43 are the front and back of a panel.

Plate 44. *St. Mary Magdalen.* Detail from Plate 9.

Plate 45. *St. John the Evangelist.* Detail from Plate 43.

Plate 46. *Christ on the Cross.* Detail from Plate 9.

Plate 47. *Head of Christ.* Detail from Plate 42.

Plate 48. *The Rose without Thorns.* Detail from Plate 14.

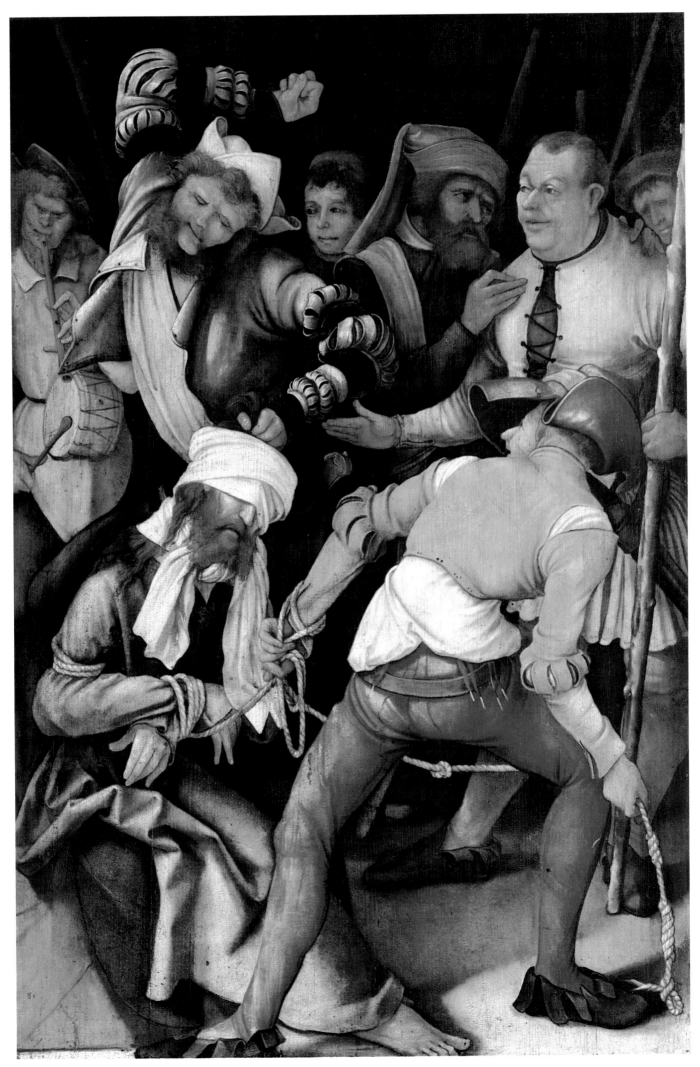

1. *The Mocking of Christ.* 1503? Munich, Alte Pinakothek

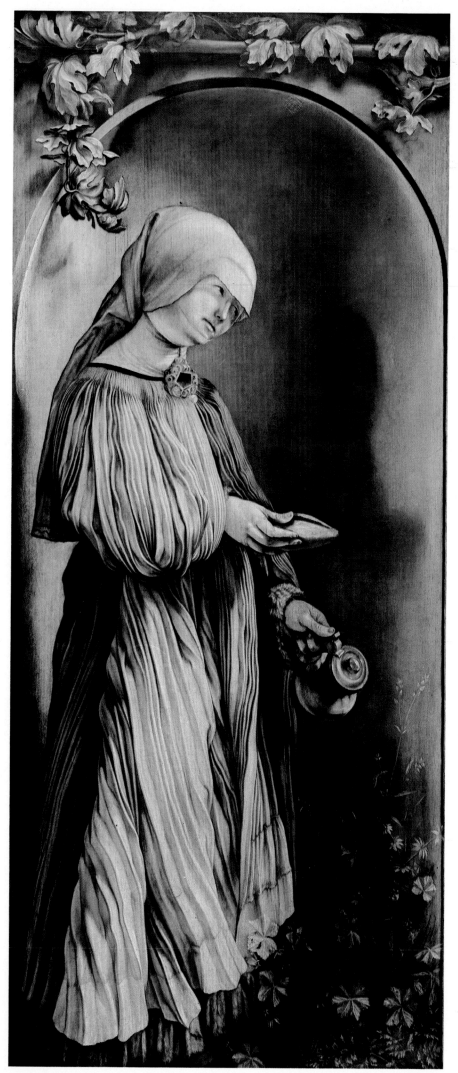

2. *St. Elizabeth of Hungary,*
wife of Ludwig of Thuringia.
1511–2. Karlsruhe, Kunsthalle
(from Donaueschingen)

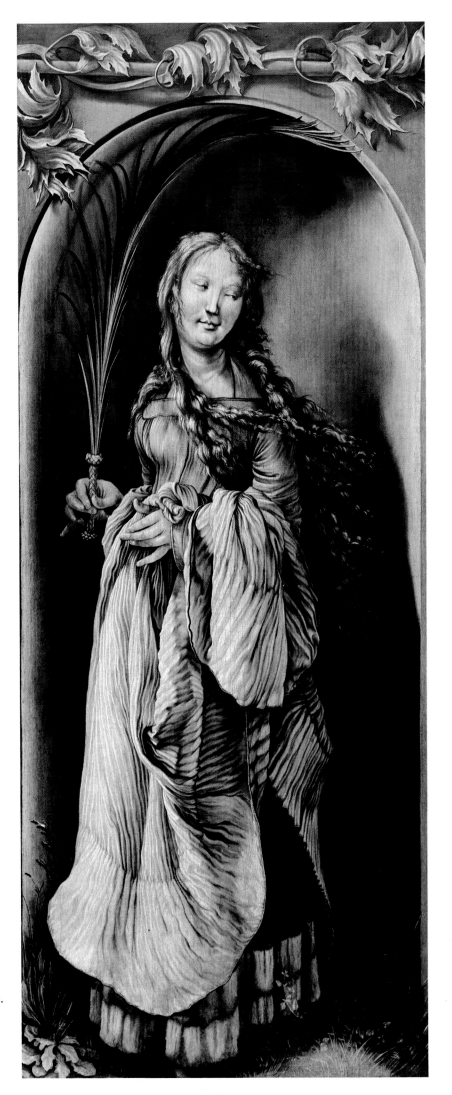

3. *St. Lucy (?) with the palm of martrydom.*
1511–2. Karlsruhe, Kunsthalle
(from Donaueschingen)

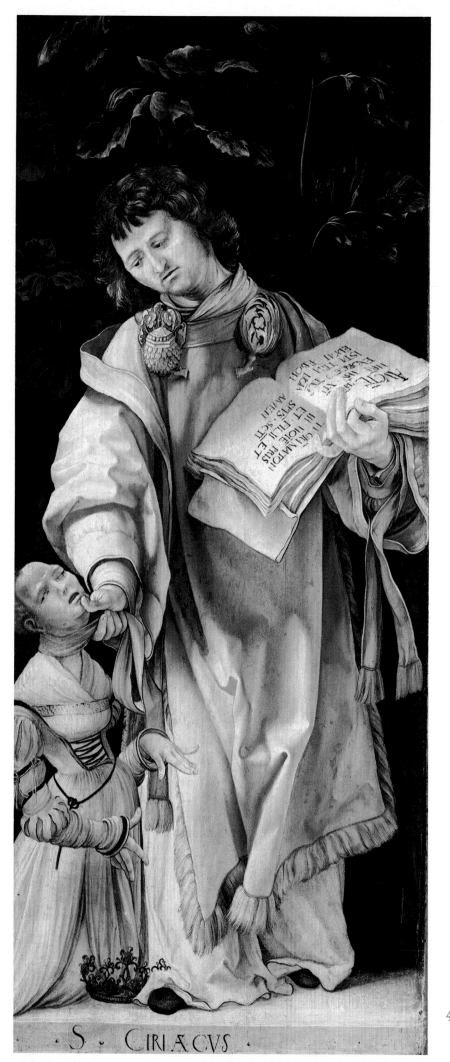

· S · CIRIÆCVS ·

4. *St. Cyriac and the Princess Artemia.* 1511–2.
Frankfurt, Staedel Institute

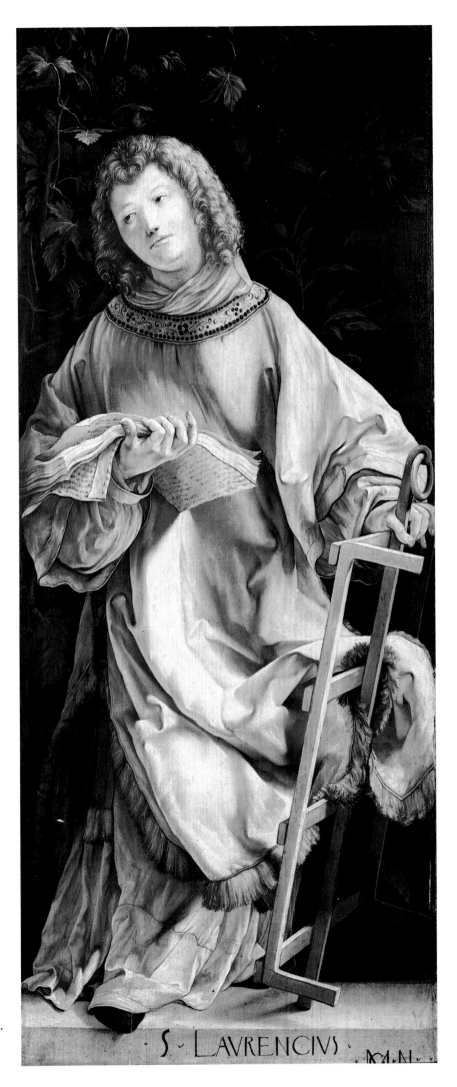

5. *St. Lawrence with the gridiron.* 1511–2.
Frankfurt, Staedel Institute

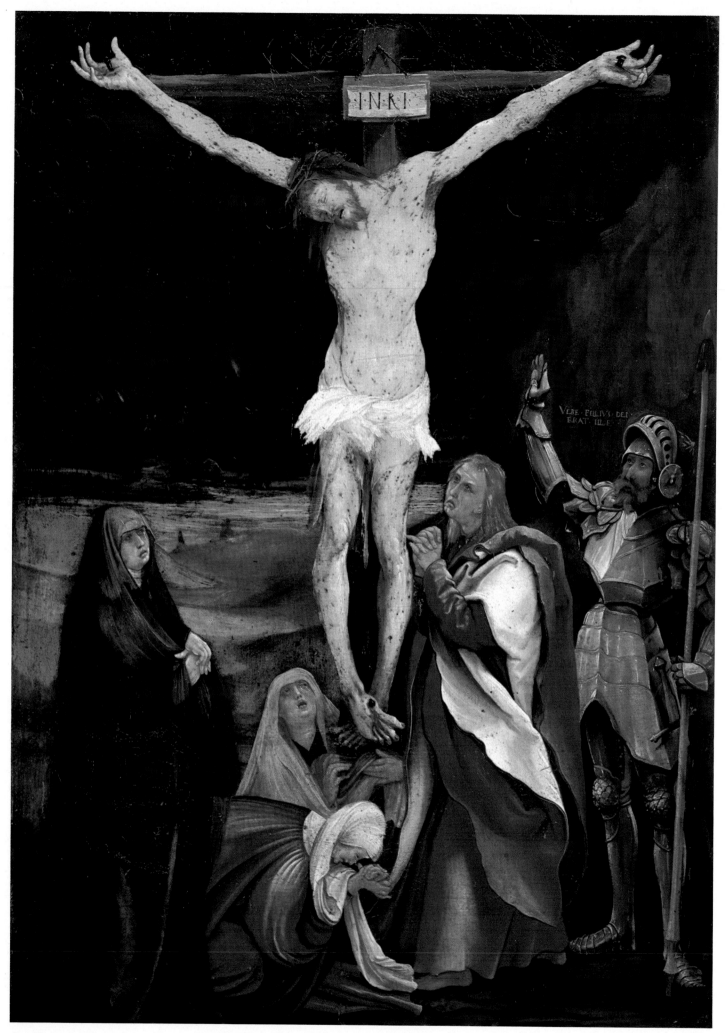

6. *Christ on the Cross, with the Three Maries, St. John the Evangelist and St. Longinus.* 1513–4? Basel, Öffentliche Kunstsammlung

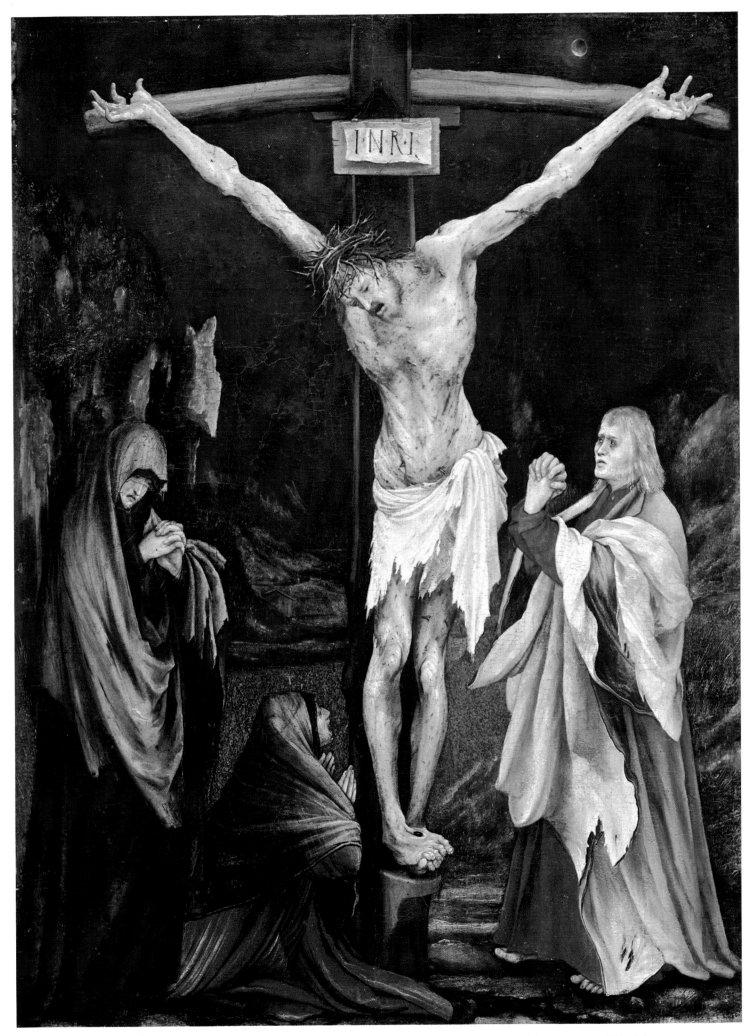

7. *Christ on the Cross, with the Virgin, St. John the Evangelist and St. Mary Magdalen.* About 1519. Washington D.C., National Gallery of Art (Samuel H. Kress Collection)

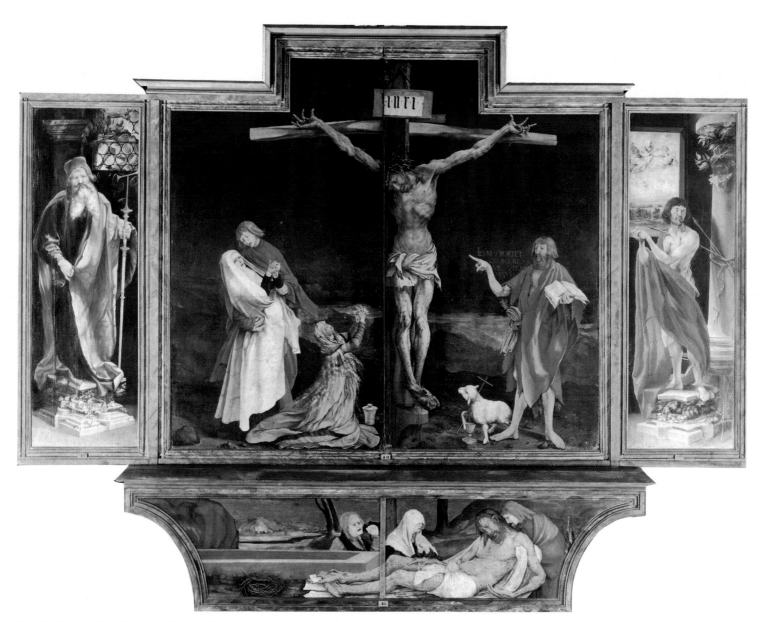

8. *Christ on the Cross, with the Virgin, St. John the Evangelist, St. Mary Magdalen and St. John the Baptist;*
St. Anthony Abbot; St. Sebastian; The Dead Christ in the Tomb, mourned by the Virgin, St. John the Evangelist
and St. Mary Magdalen. Colmar, Unterlinden Museum

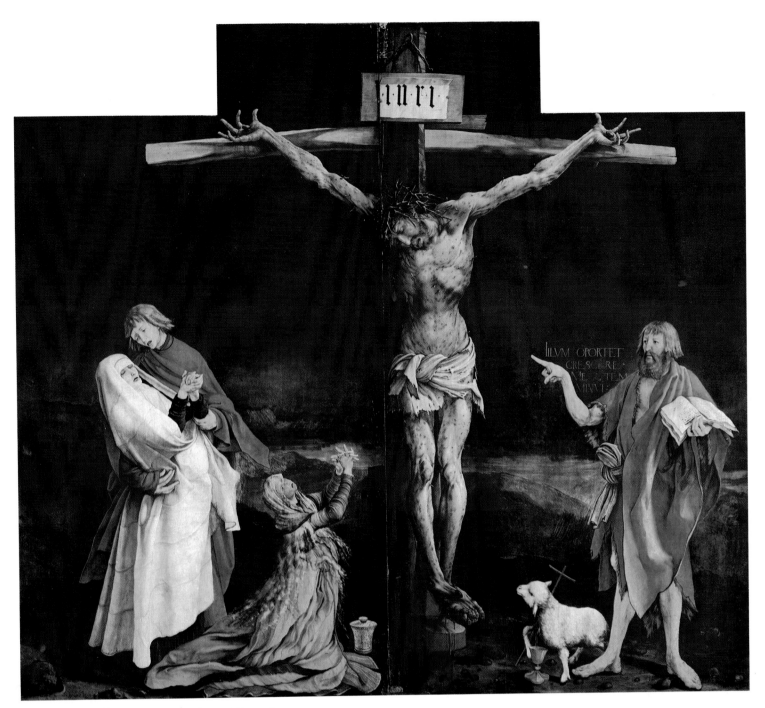

9. *Christ on the Cross*. Detail from Plate 8

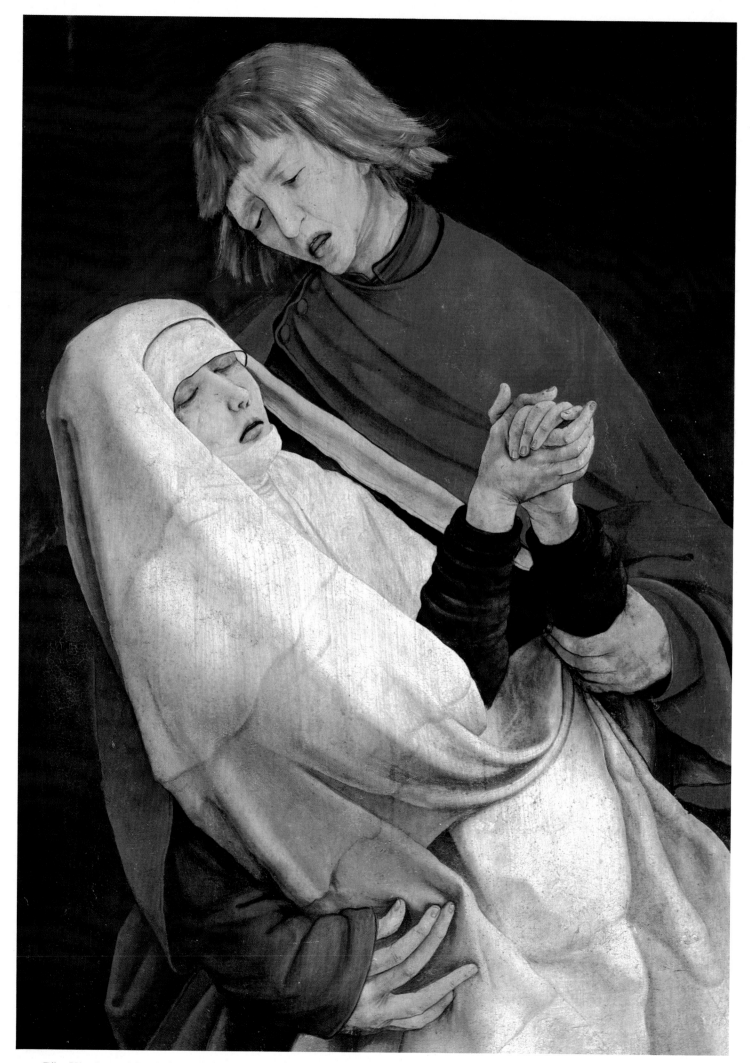

10. *The Virgin and St. John the Evangelist*. Detail from Plate 9

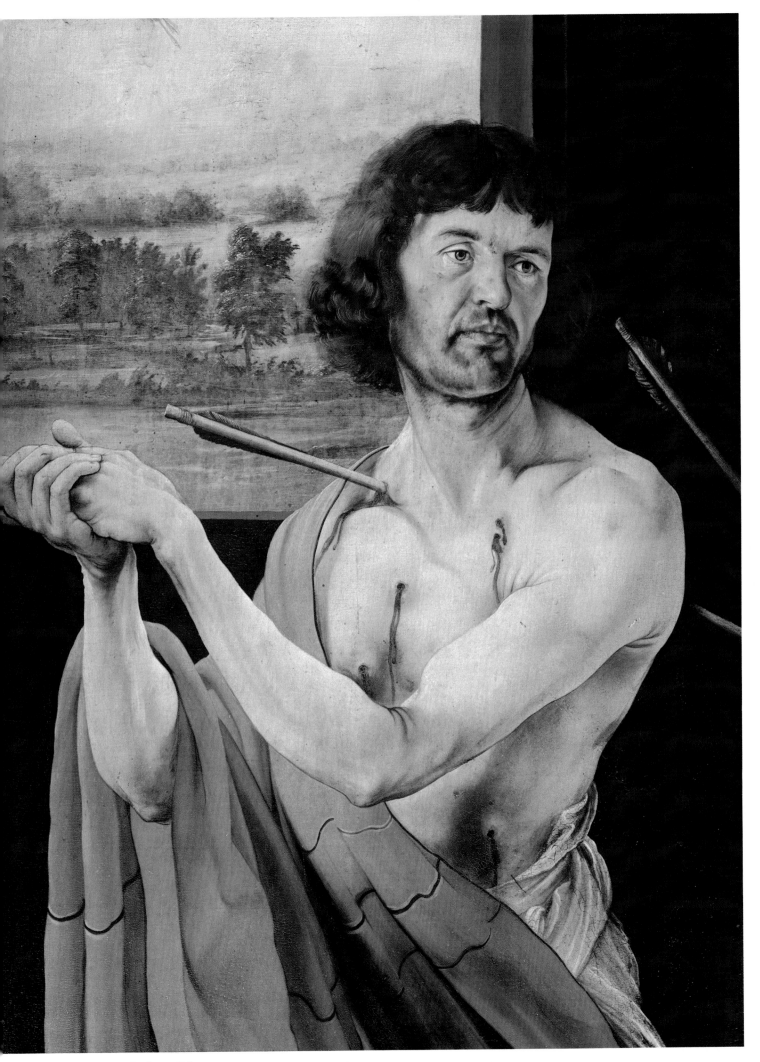

St. Sebastian. Detail from Plate 13

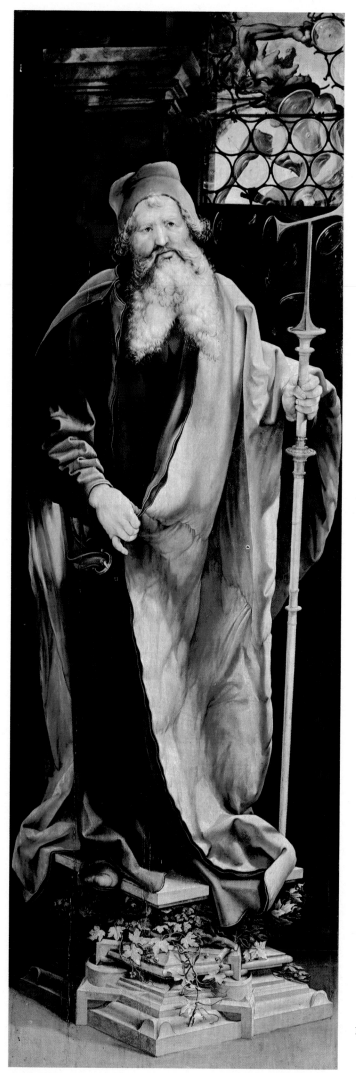

12. *St. Anthony Abbot*. Detail from Plate 8

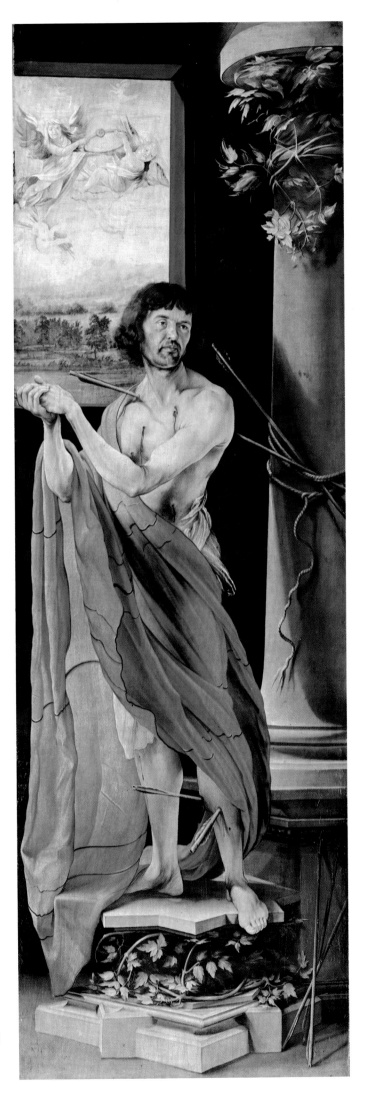

13. *St. Sebastian.* Detail from Plate 8

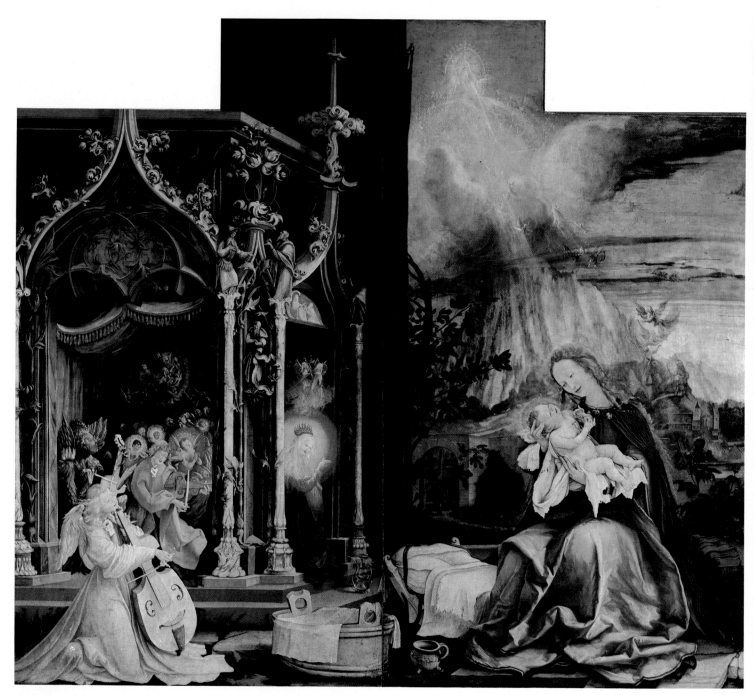

14. *The Virgin and Child with Angels making music* (The Isenheim Altarpiece). Colmar, Unterlinden Museum

15. *Angels making music.* Detail from Plate 14

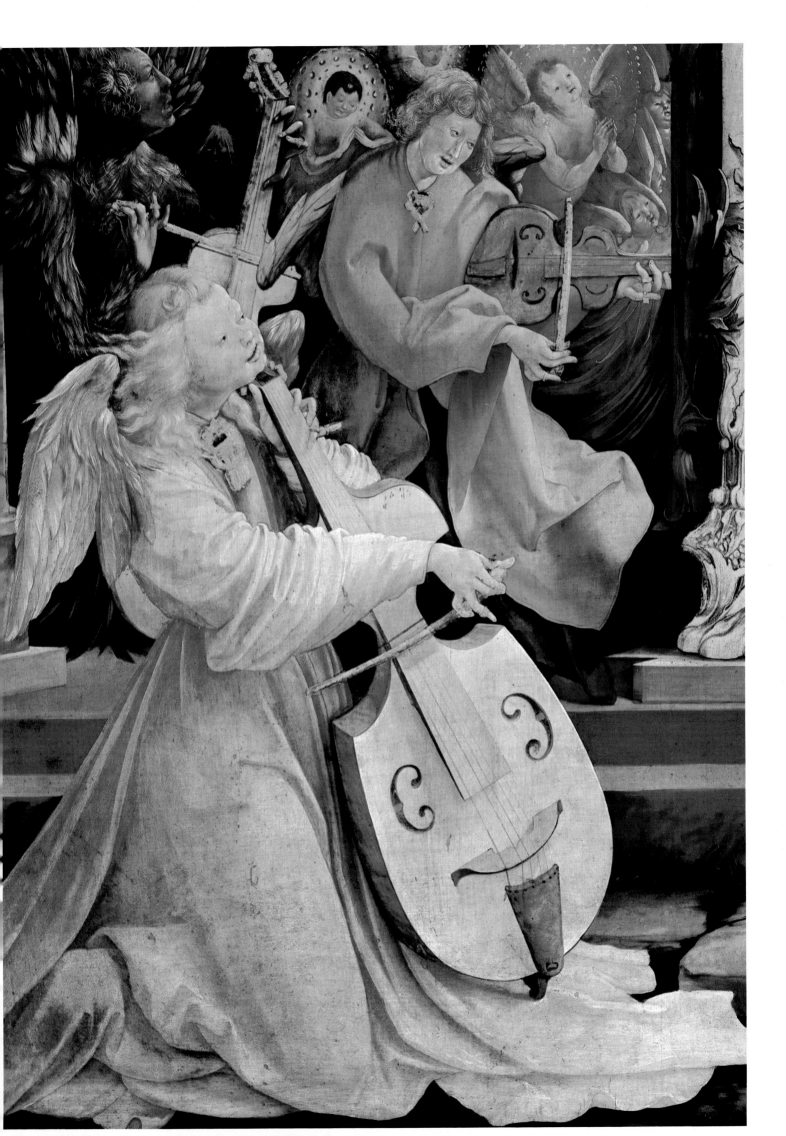

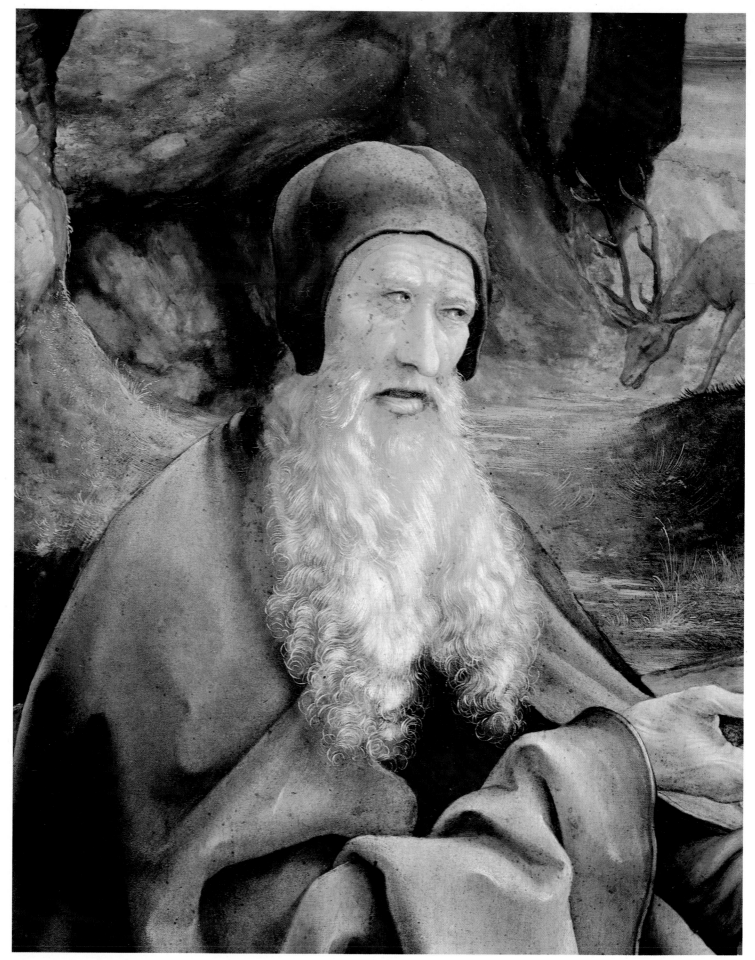

16. *St. Anthony Abbot*. Detail from Plate 26

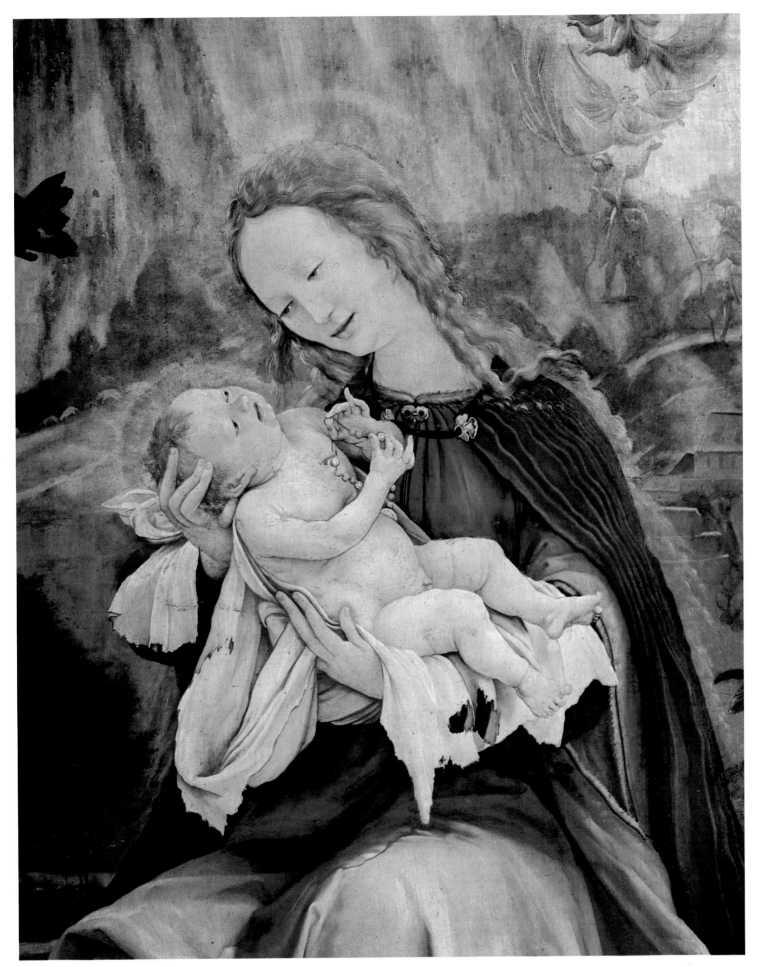

17. *The Virgin and Child*. Detail from Plate 14

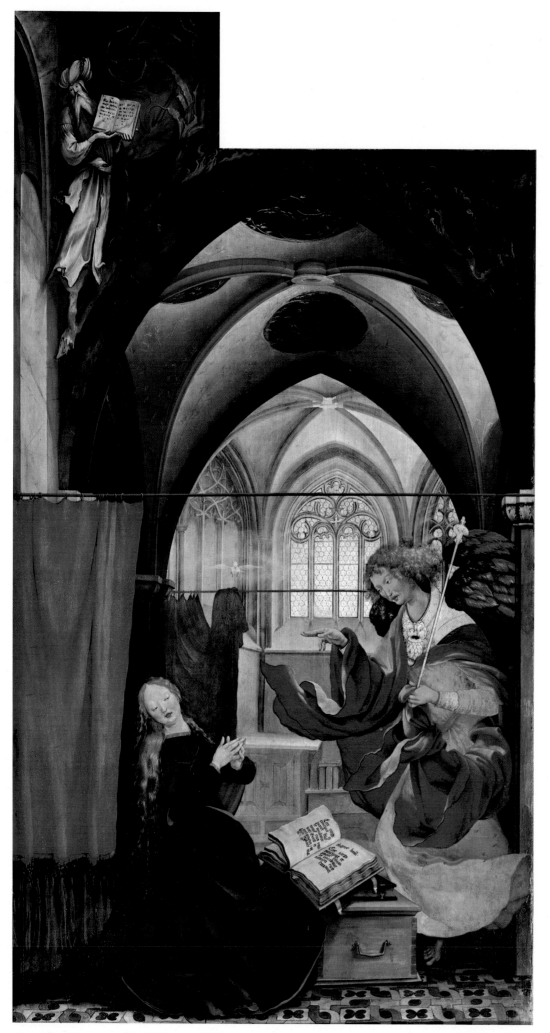

18. *The Annunciation* (Wing of the Isenheim Altarpiece). Colmar, Unterlinden
Museum

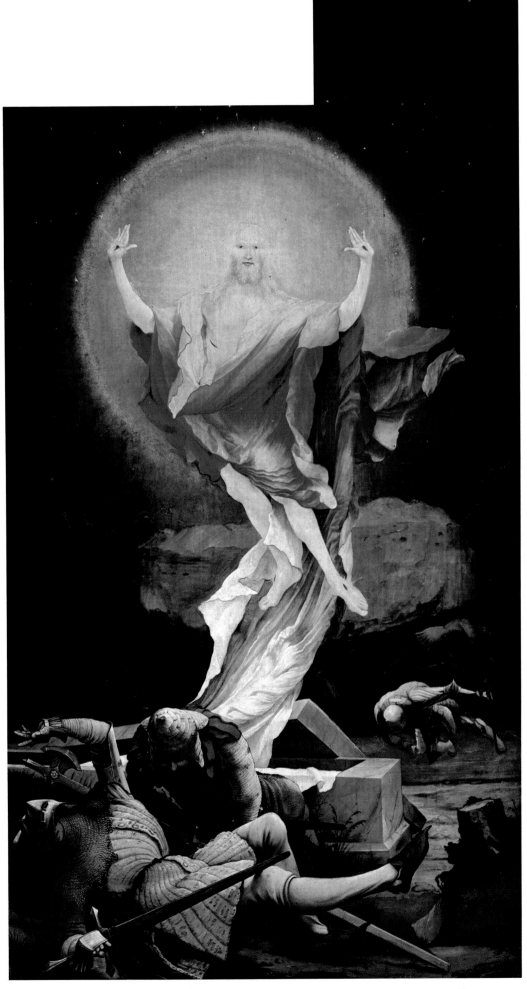

19. *The Resurrection* (Wing of the Isenheim Altarpiece). Colmar, Unterlinden Museum

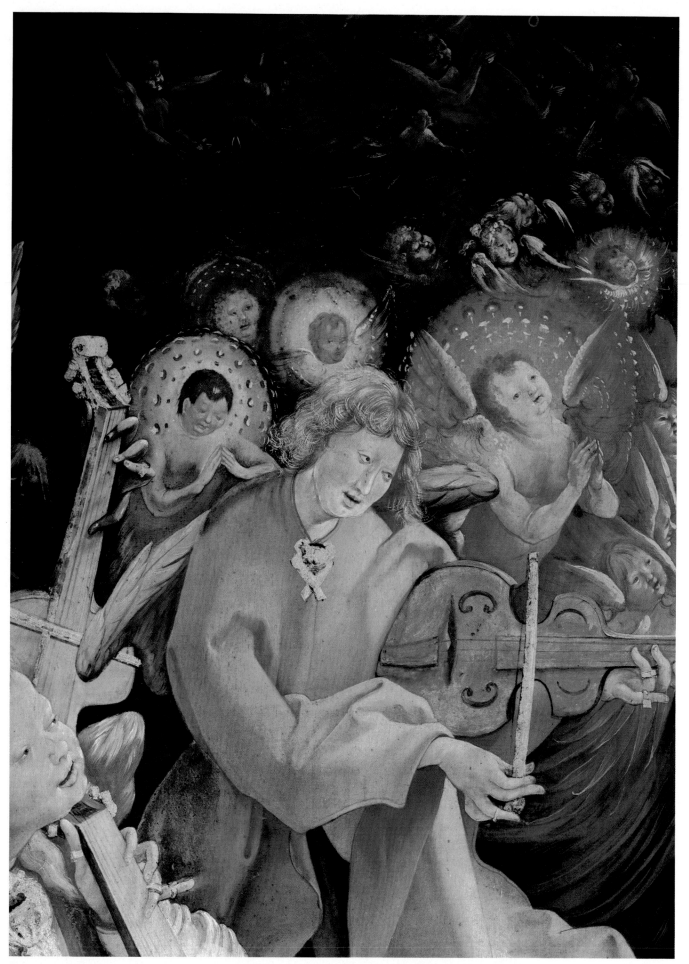

20. *Angels making music*. Detail from Plate 14

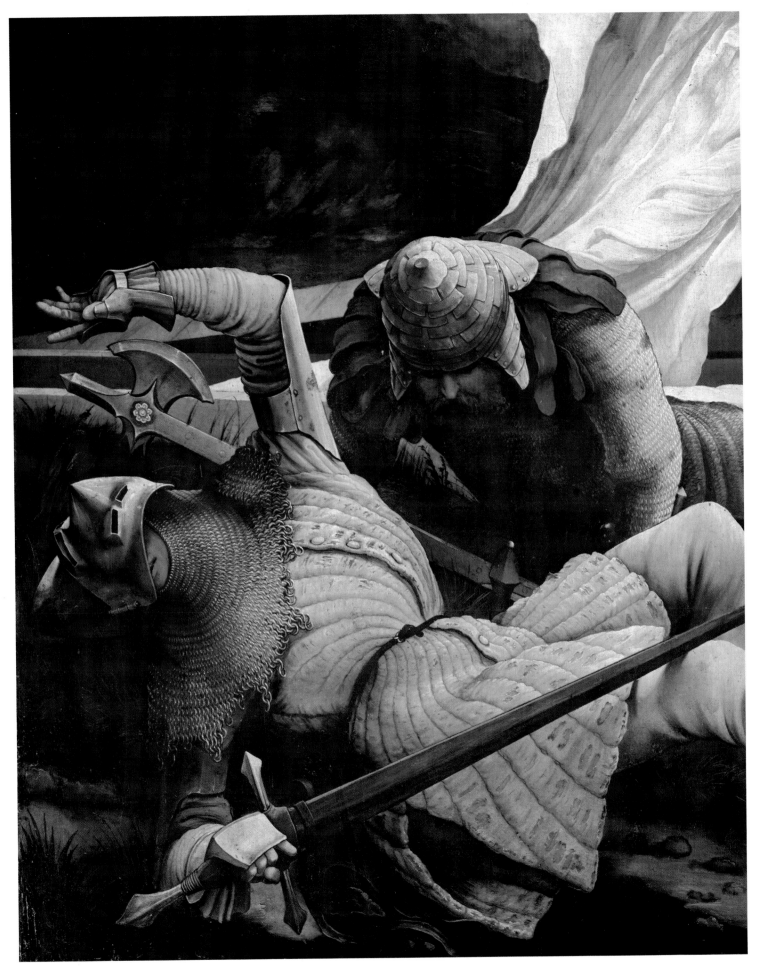

21. *Two soldiers*. Detail from Plate 19

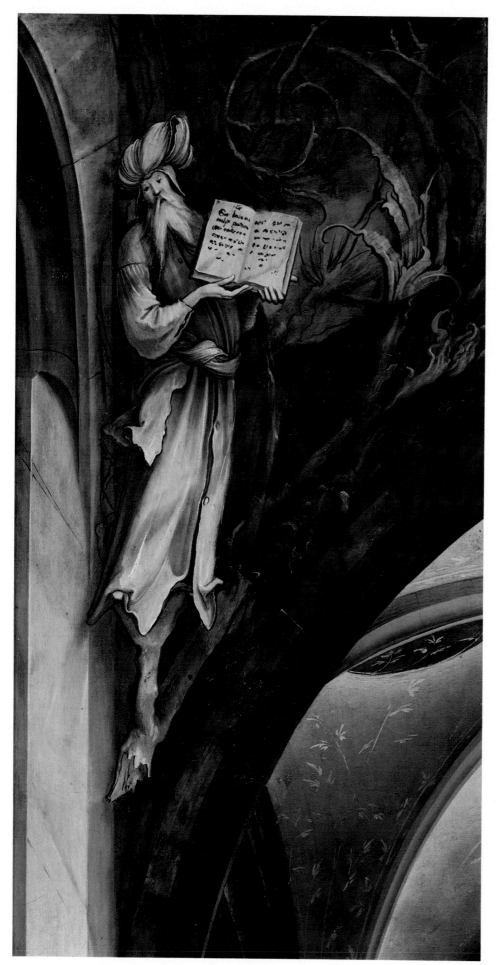

22. *The Prophet Isaiah*. Detail from Plate 18

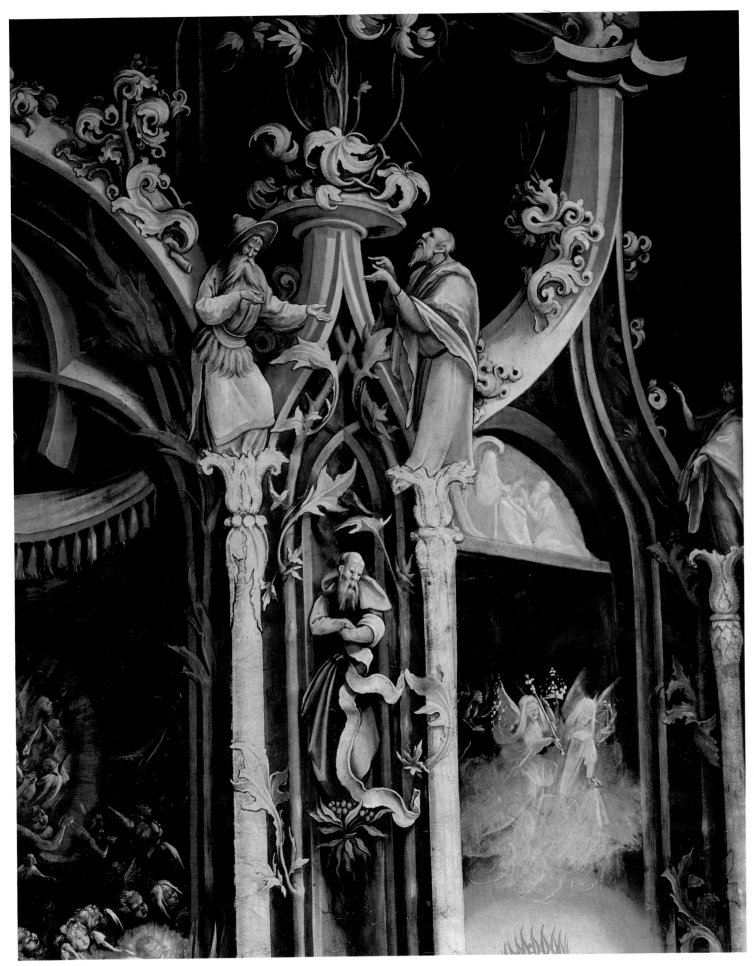

23. *Three Prophets.* Detail from Plate 14

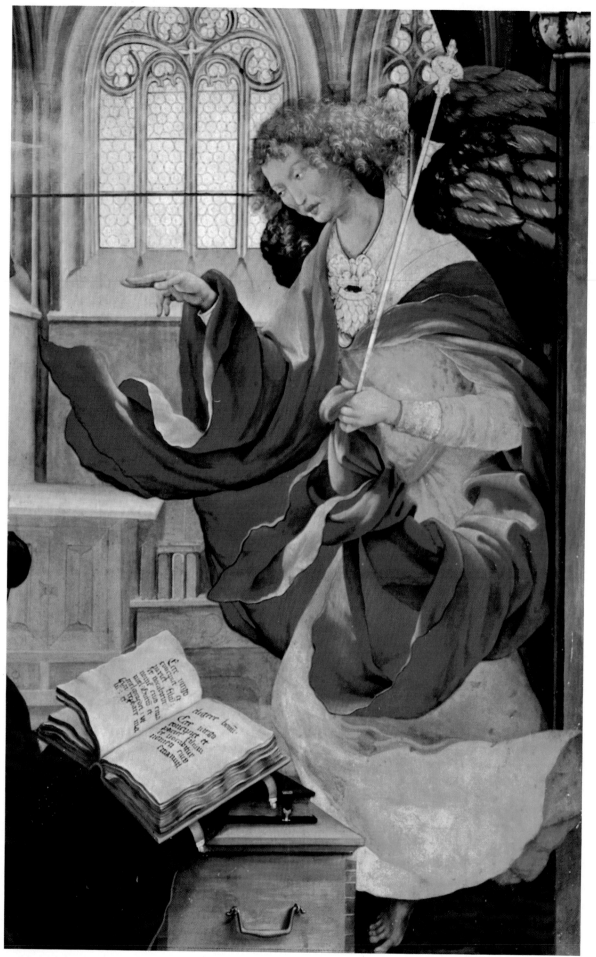

24. *The Archangel Gabriel.* Detail from Plate 18

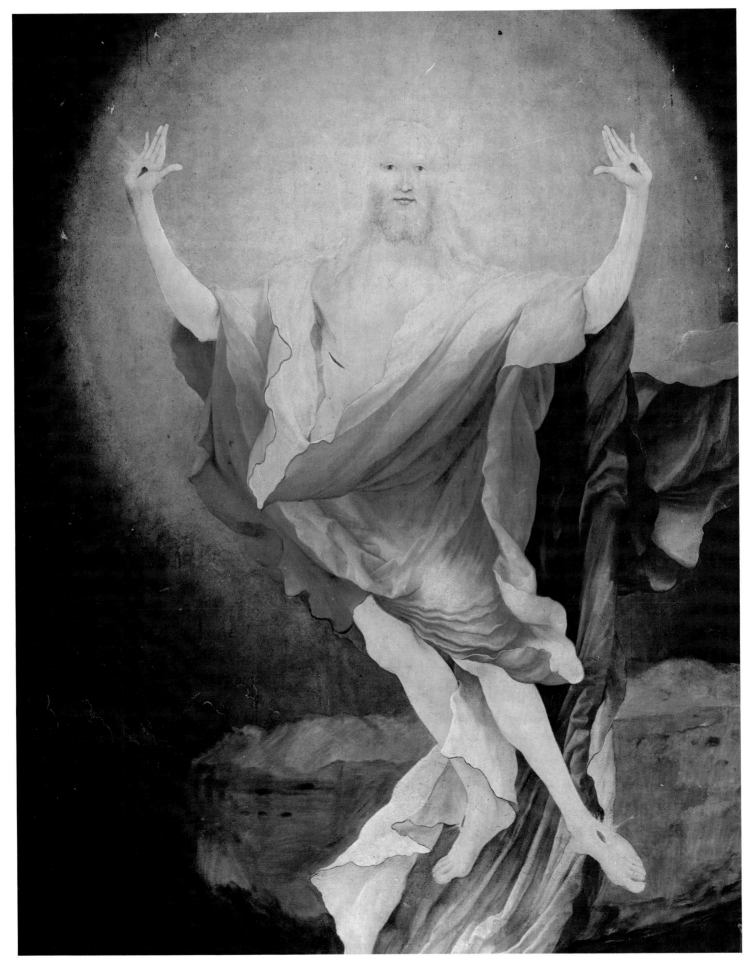

25. *The Risen Christ*. Detail from Plate 19

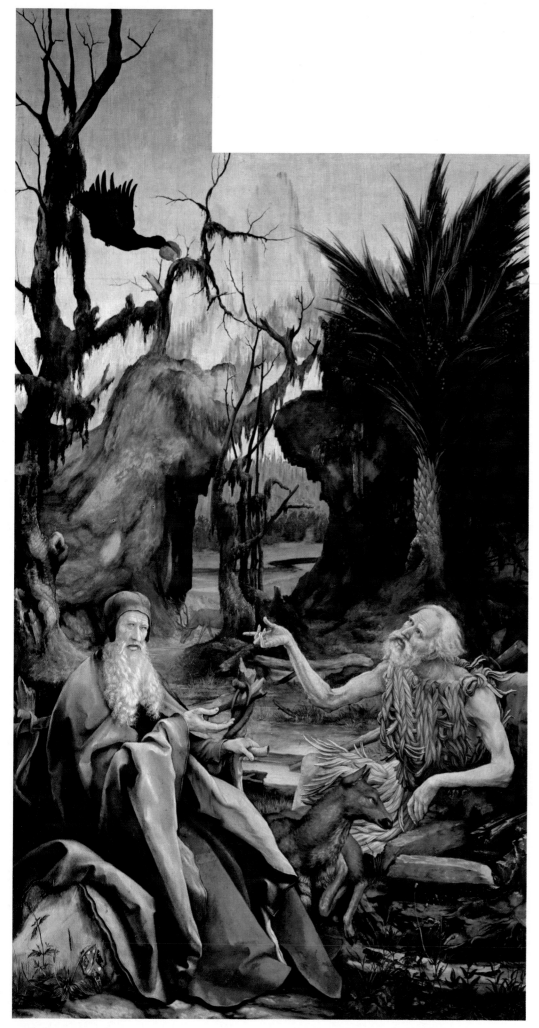

26. *The Meeting of St. Anthony Abbot and St. Paul the Hermit in the Wilderness*
(Wing of the Isenheim Altarpiece). Colmar, Unterlinden Museum

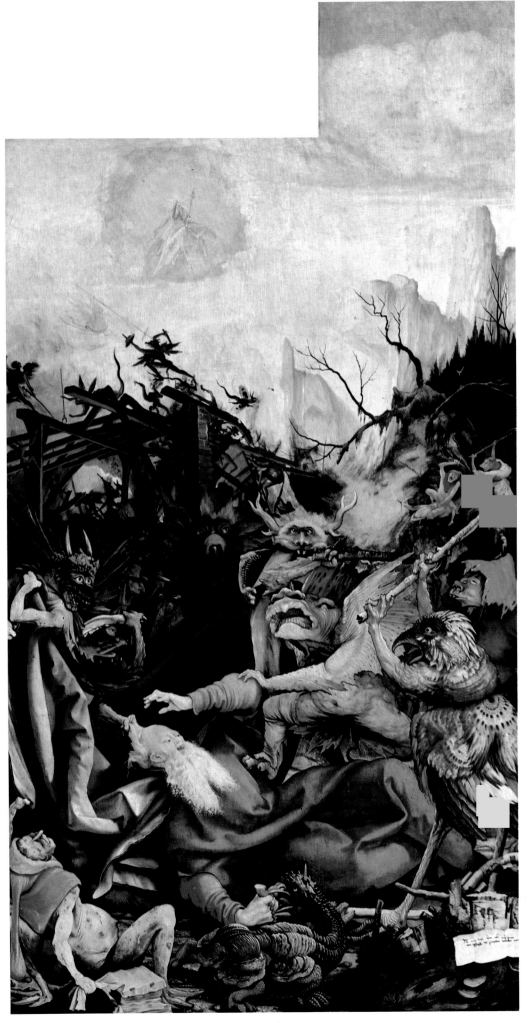

27. *St. Anthony Abbot assailed by monstrous demons*
 (Wing of the Isenheim Altarpiece). Colmar, Unterlinden Museum

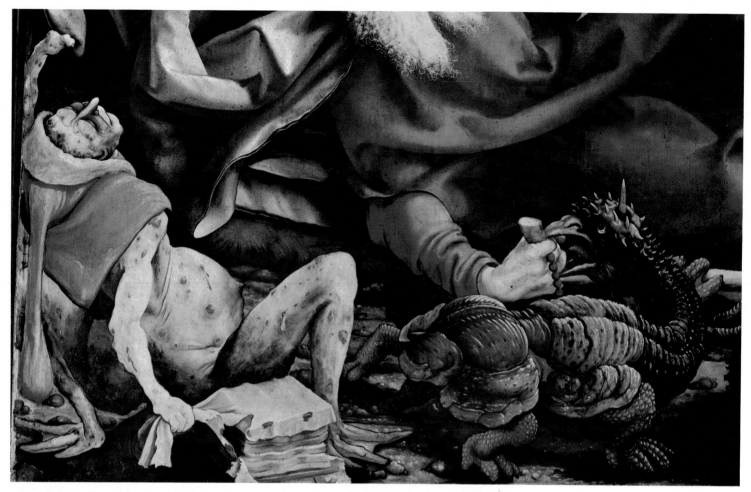

28a. *Man afflicted by St. Anthony's fire, and a monstrous demon.* Detail from Plate 27

28b. *Overgrown stone base.* Detail from Plate 12

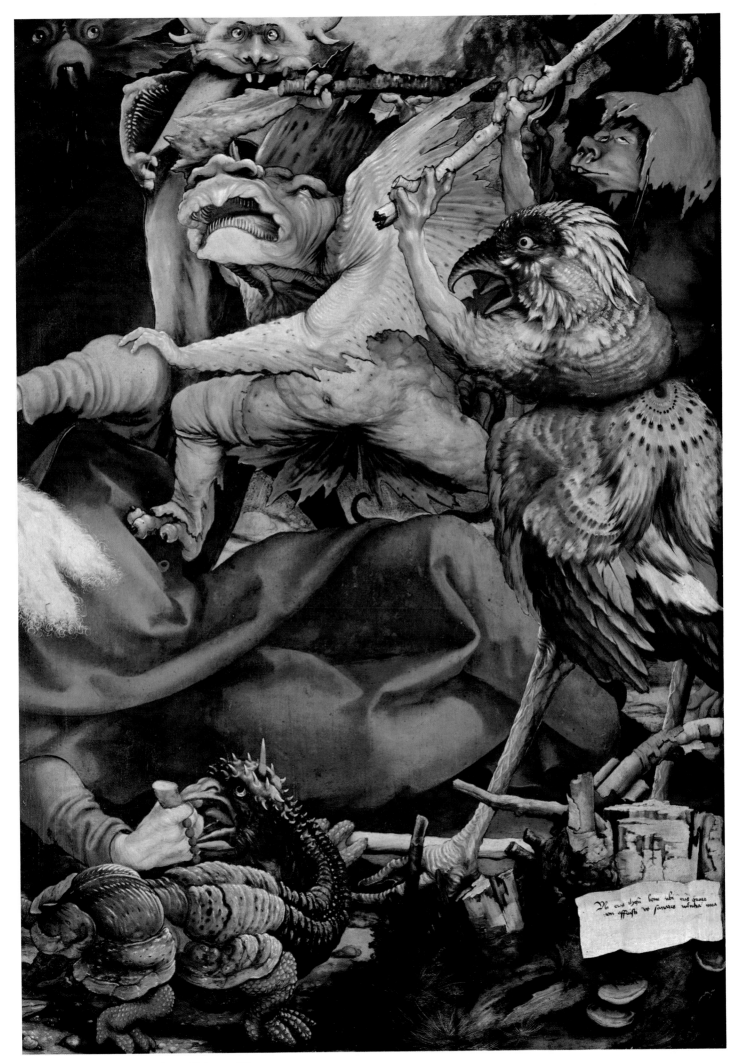

29. *Monstrous demons*. Detail from Plate 27

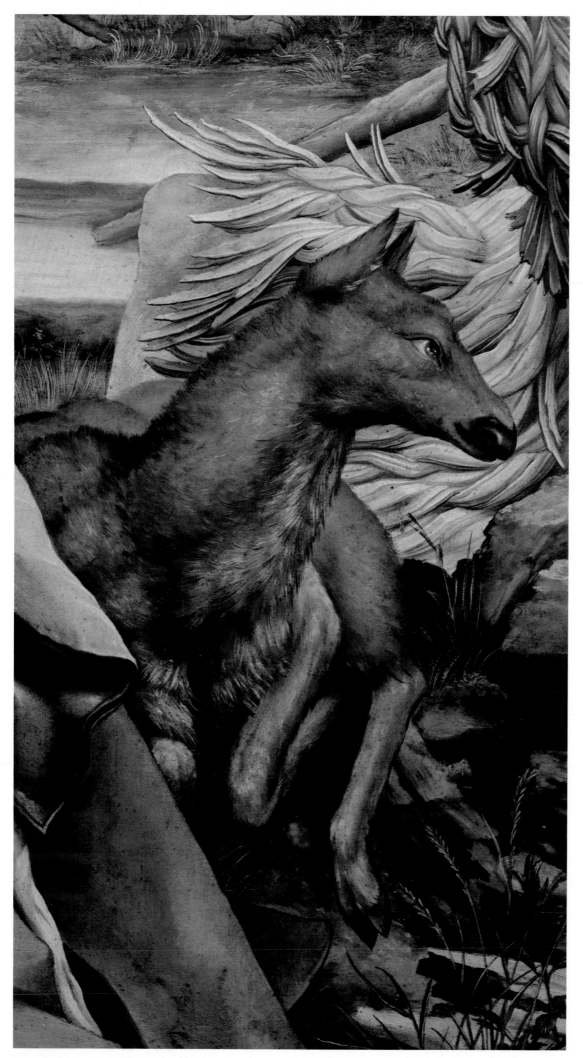

30. *Deer*. Detail from Plate 26

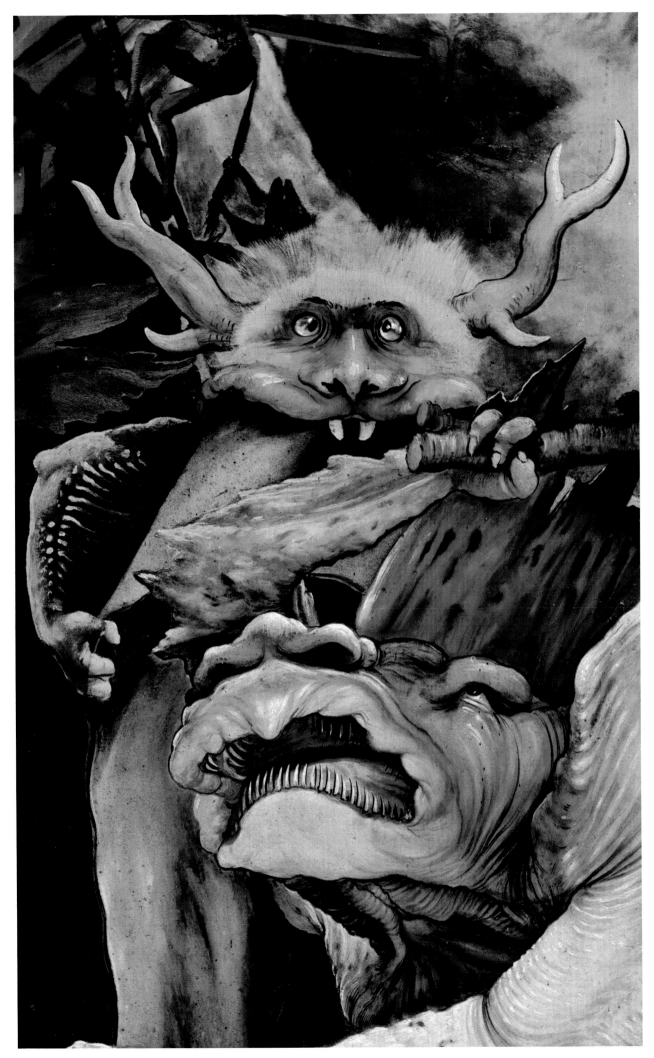

31. *Monstrous demons*. Detail from Plate 27

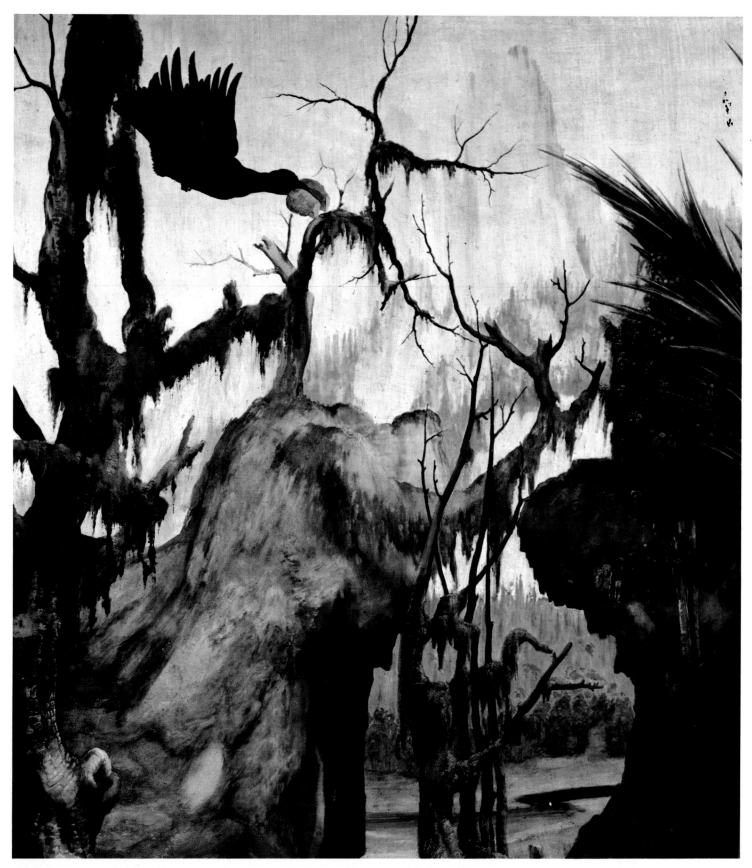

32. *Raven bringing bread to St. Anthony Abbot and St. Paul the Hermit*. Detail from Plate 26

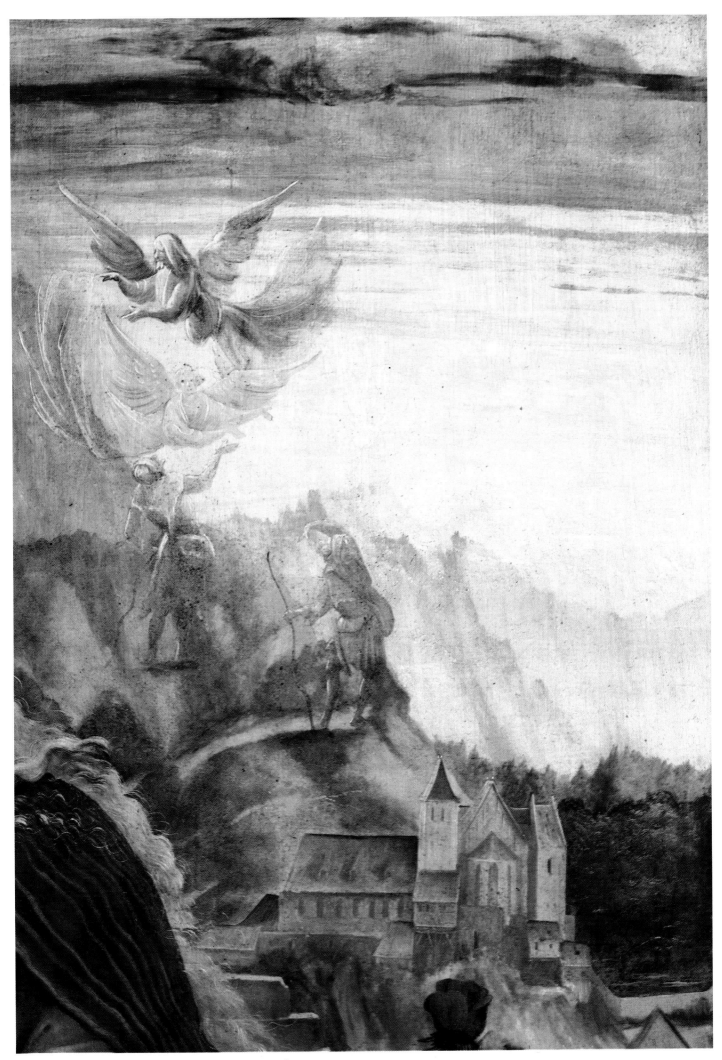

33. *Landscape with monastery and a vision of angels.* Detail from Plate 34

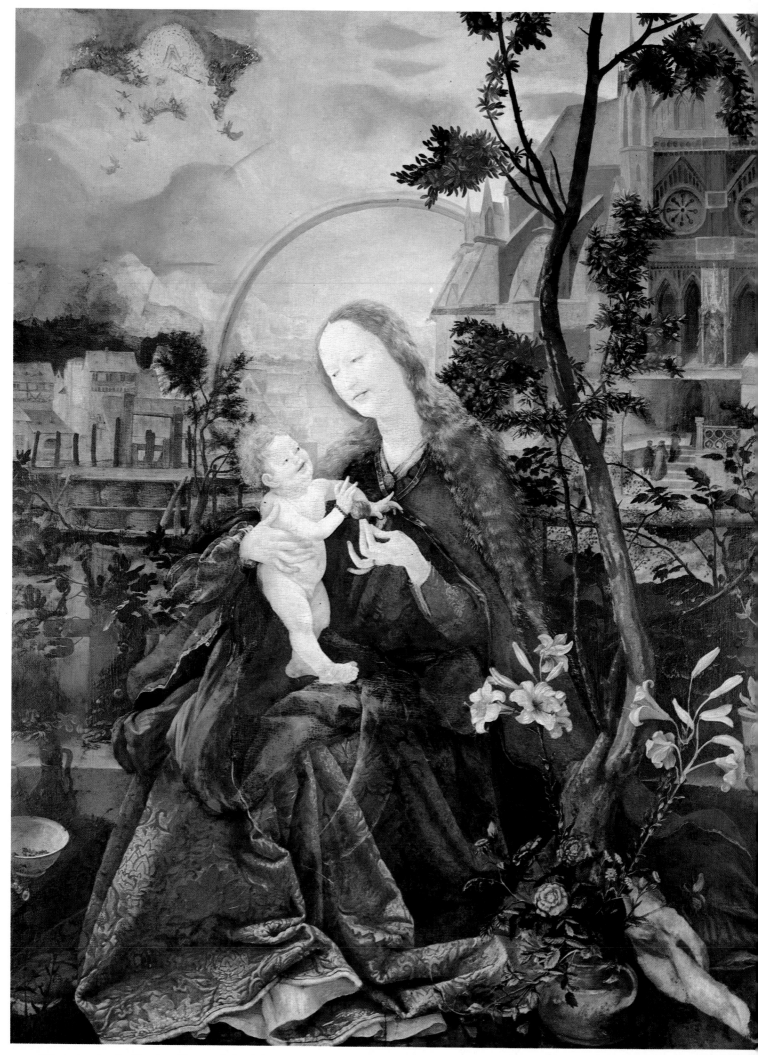

34. *Madonna in the Garden* (Part of the Maria-Schnee Altarpiece). 1517–9. Stuppach (Württemberg) Parish Church

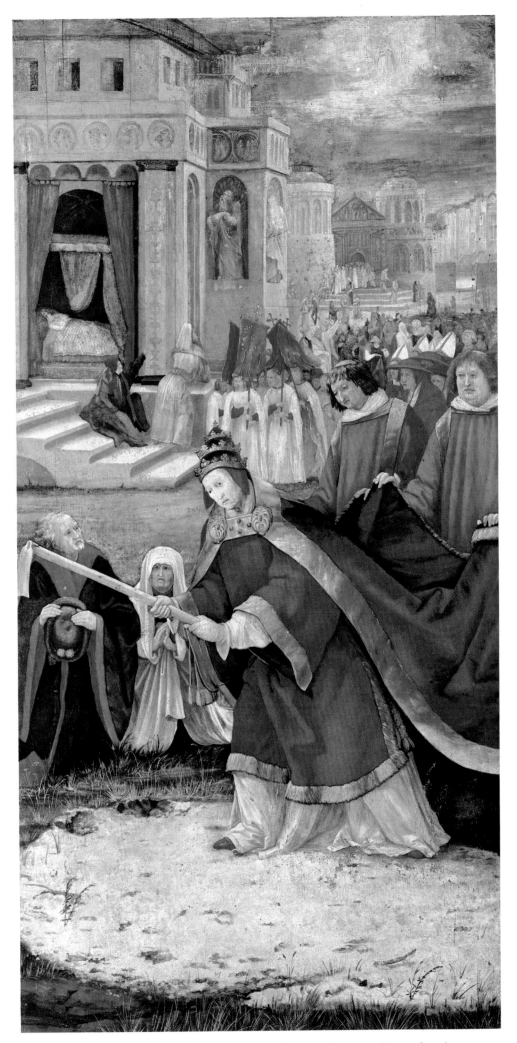

35. *The Miracle of the Snows* (Part of the Maria-Schnee Altarpiece).
1517–9. Freiburg im Breisgau, Augustinermuseum

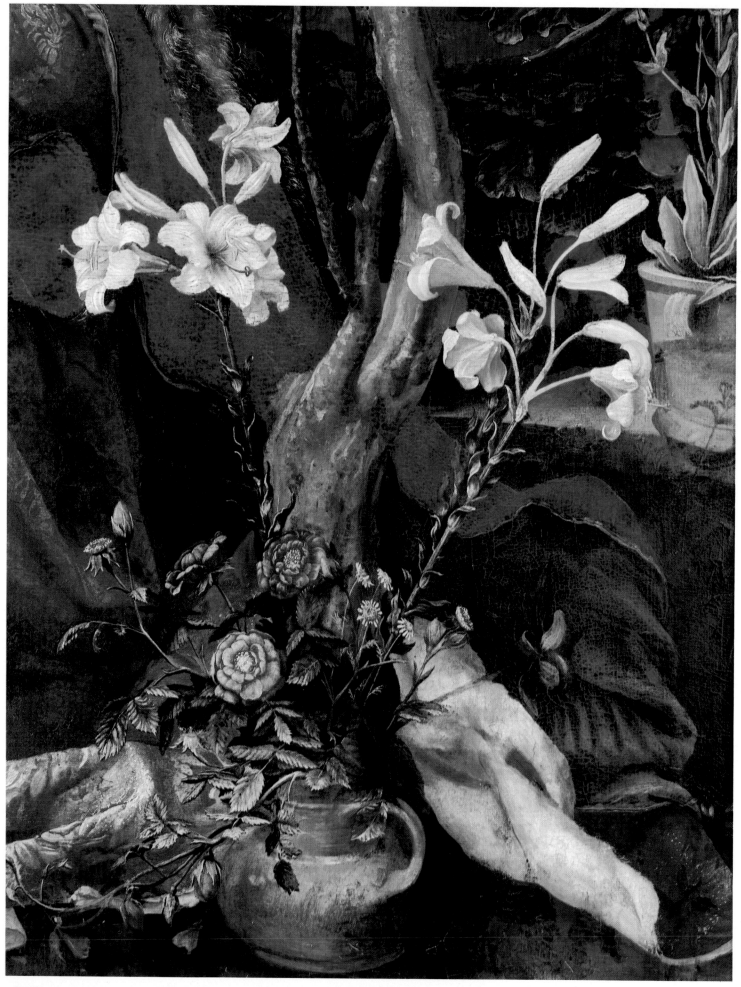

36. *Vase of lilies and roses*. Detail from Plate 34

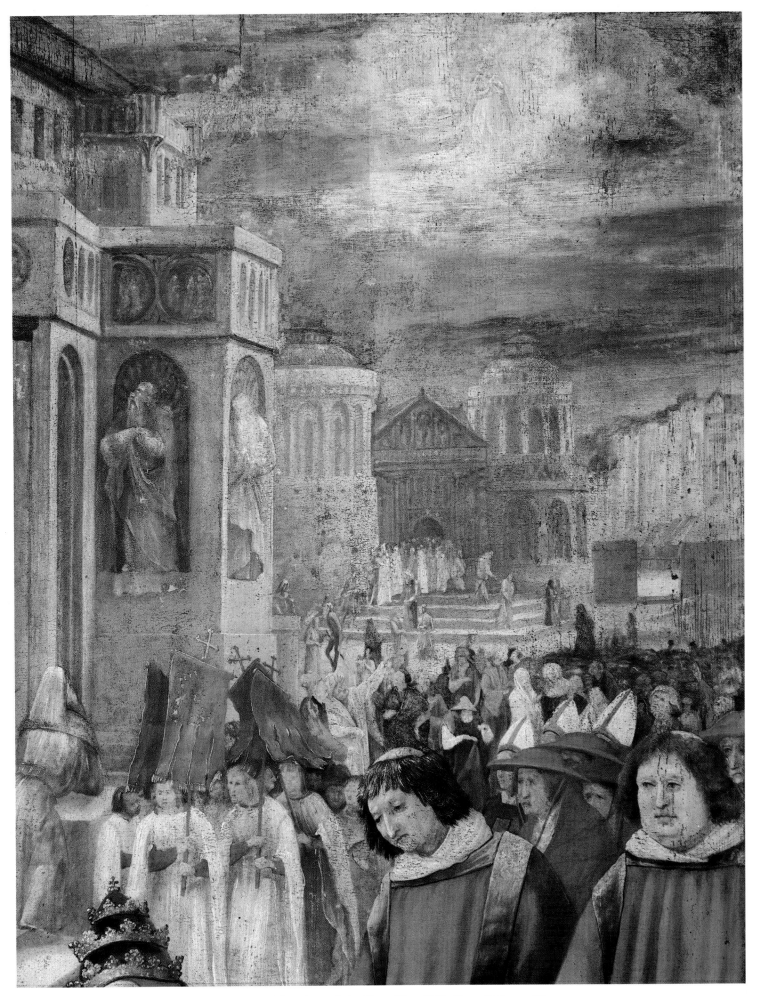

37. *The retinue of Pope Liberius and a fanciful view of the Esquiline Hill.* Detail from Plate 35

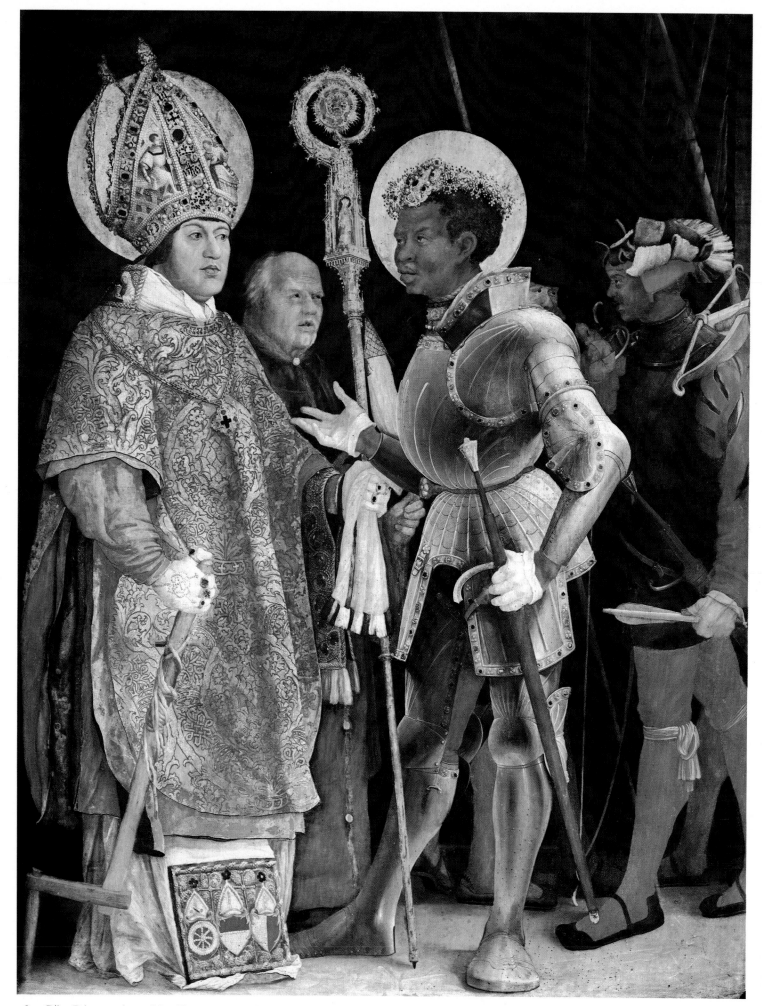

38. *The Disputation of St. Erasmus and St. Maurice.* 1524–5. Munich, Alte Pinakothek

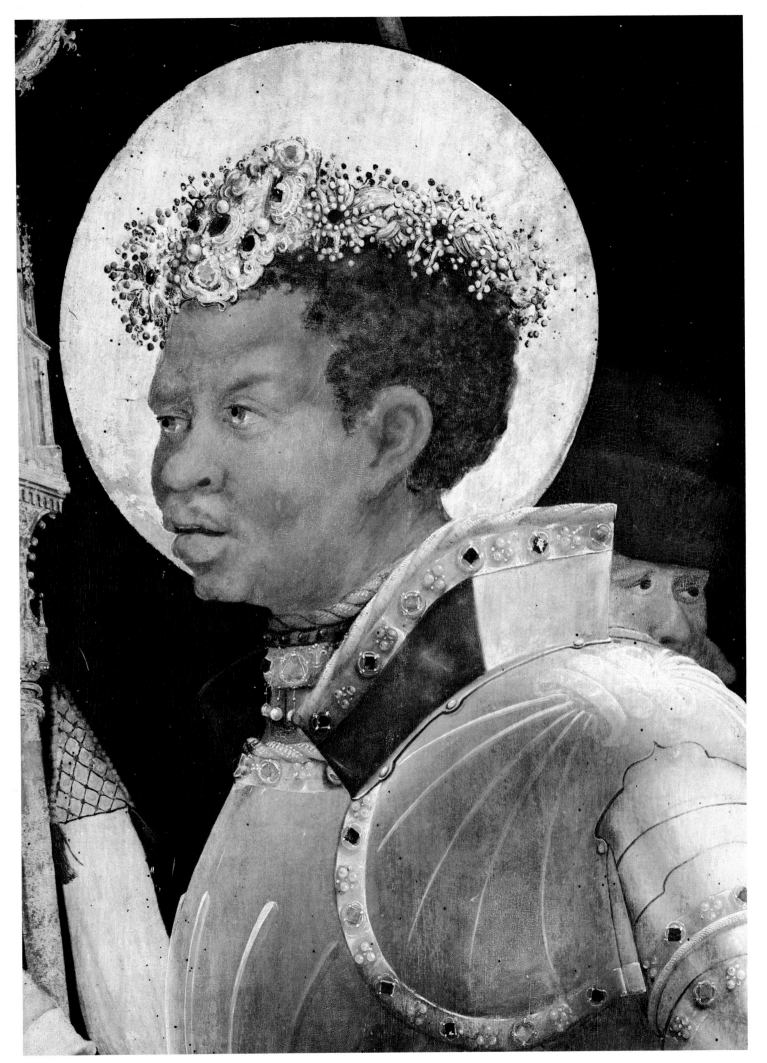

39. *St. Maurice*. Detail from Plate 38

40. *Dead Christ.* 1523? Aschaffenburg, Collegiate Church

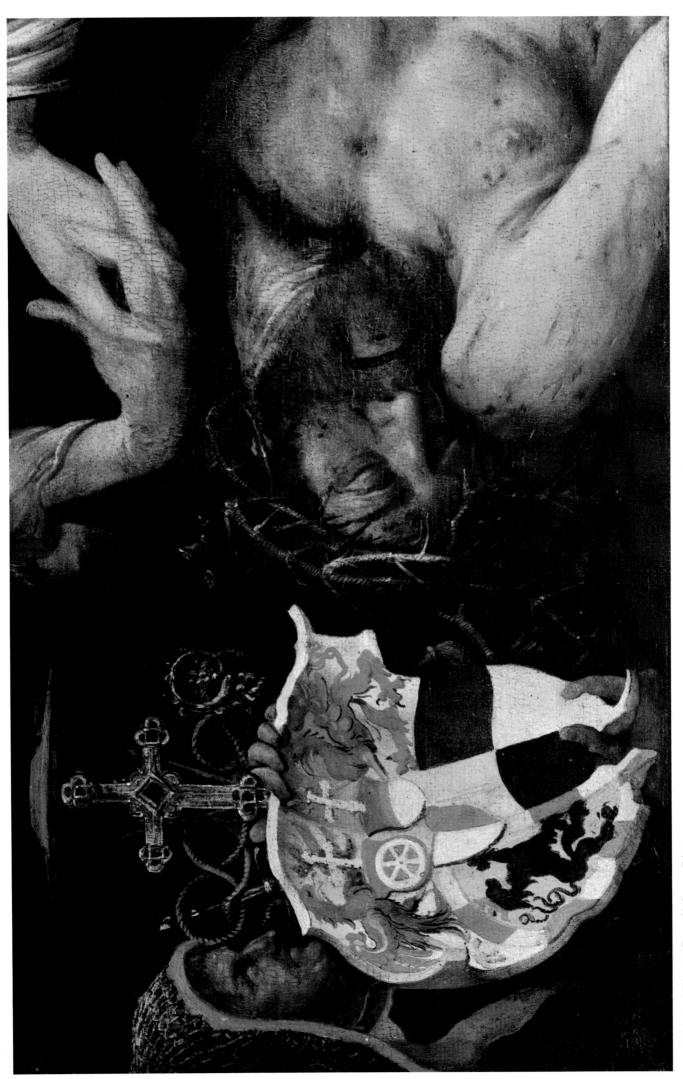

41. *Head of Christ*. Detail from Plate 40

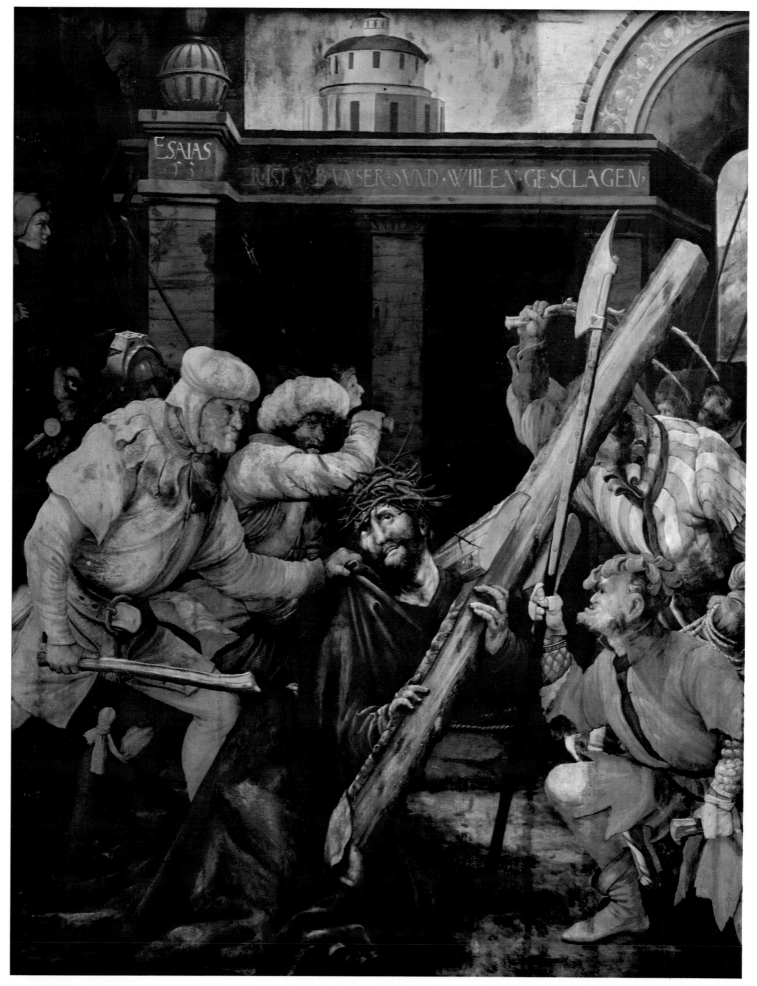

Within the image: ESAIAS / ...IST VMB VNSER SVND WILLEN GESCLAGEN

42. *Christ carrying the Cross*. About 1526. Karlsruhe, Kunsthalle

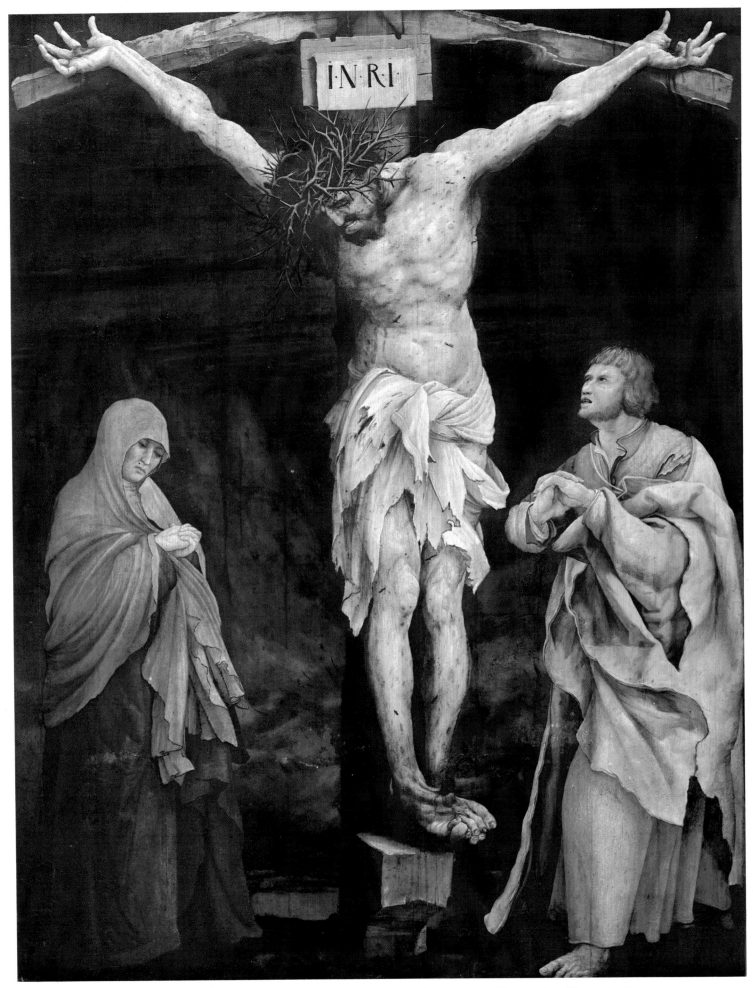

43. *Christ on the Cross, with the Virgin and St. John the Evangelist.* About 1526. Karlsruhe, Kunsthalle

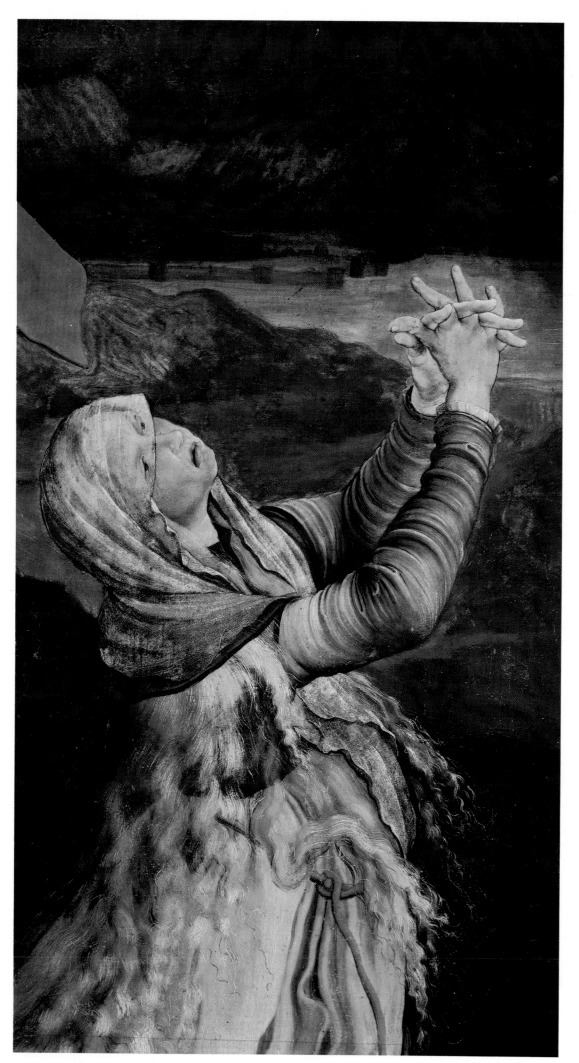

44. *St. Mary Magdalen*. Detail from Plate 9

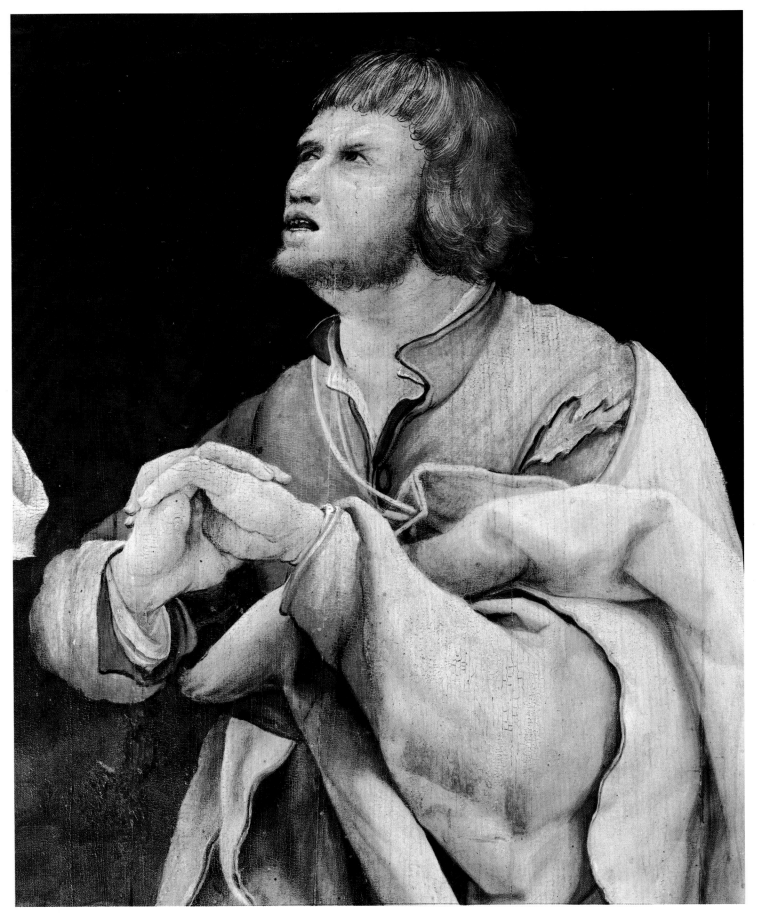

45. *St. John the Evangelist*. Detail from Plate 43

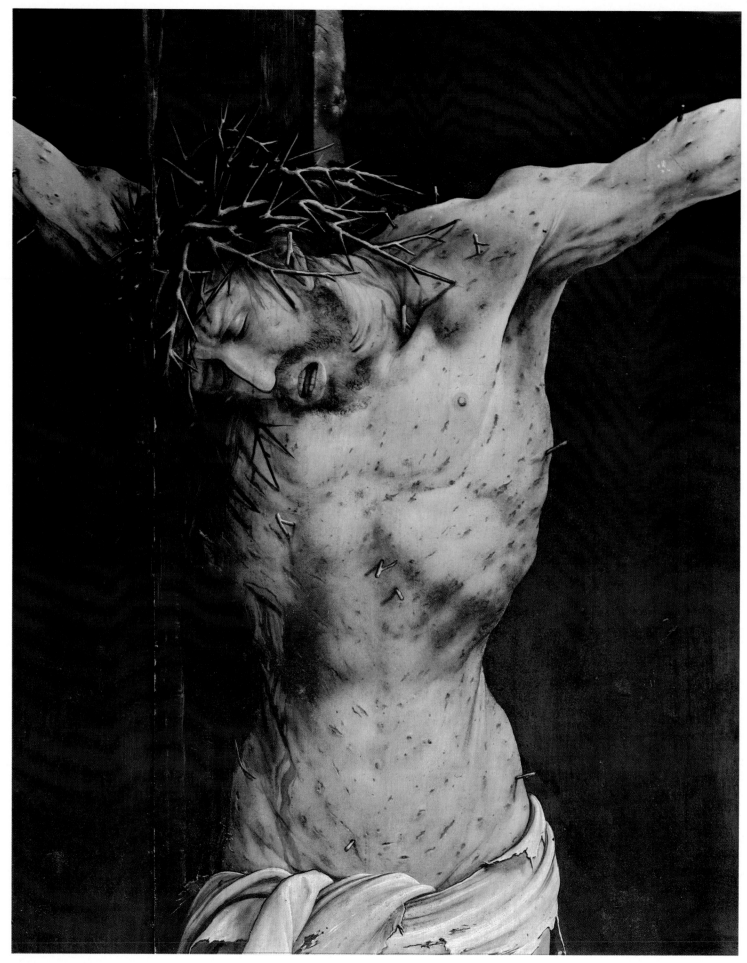

46. *Christ on the Cross*. Detail from Plate 9

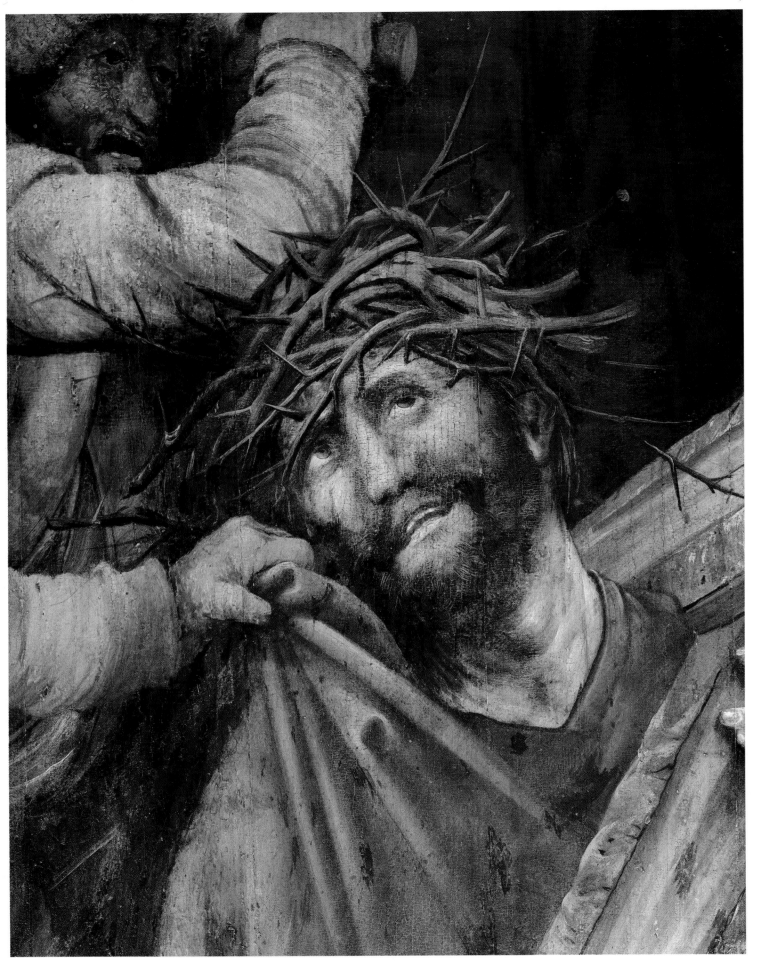

47. *Head of Christ*. Detail from Plate 42

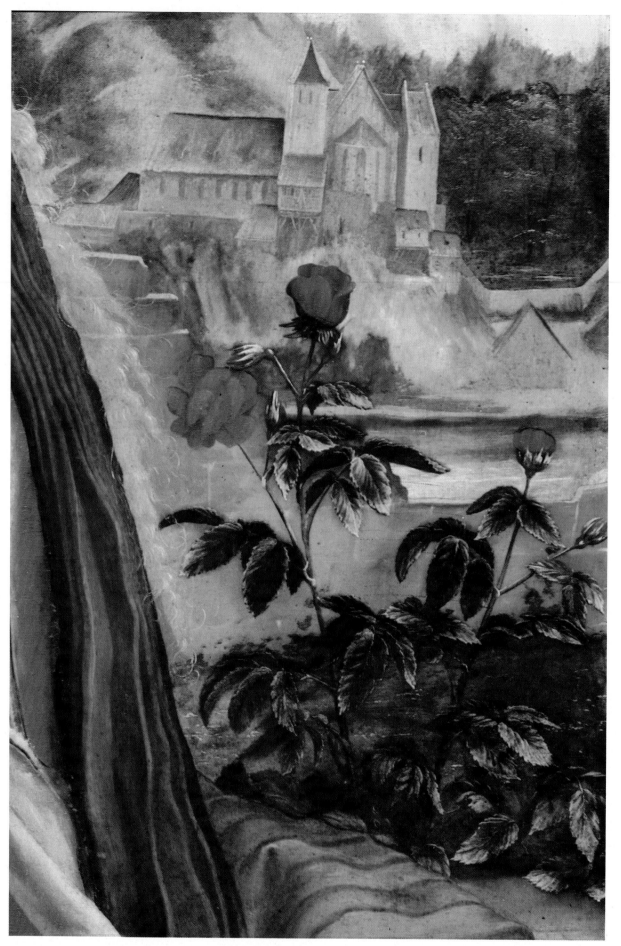

48. *The Rose without Thorns*. Detail from Plate 14